CONWY'S MILITARY HERITAGE

Adrian Hughes

AMBERLEY

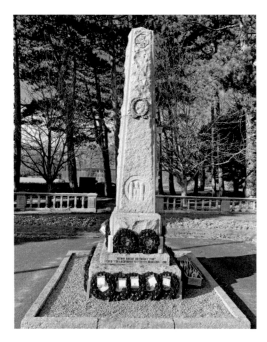

Conwy's war memorial was originally sited in Castle Square but was removed to Bodlondeb Park in the 1950s after a change to the road layout.

For Mabel – running free

First published 2024

Amberley Publishing
The Hill, Stroud
Gloucestershire, GL5 4EP

www.amberley-books.com

Copyright © Adrian Hughes, 2024

Logo source material courtesy of Gerry van Tonder

The right of Adrian Hughes to be identified as the Author of this work has been asserted in accordance with the Copyrights, Designs and Patents Act 1988.

ISBN 978 1 3981 0478 5 (print)
ISBN 978 1 3981 0479 2 (ebook)

British Library Cataloguing in Publication Data.
A catalogue record for this book is available from the British Library.

Origination by Amberley Publishing.
Printed in Great Britain.

Contents

Introduction

Lancastrian poet John Critchley Prince mused in the midst of the nineteenth century: 'Oh! For a pure and tranquil life; Upon thy banks, sweet Conway! Afar from towns of sin and strife, Upon thy banks, sweet Conway! With one unchanged companion nigh, to watch me with affection's eye, how calmly could I live and die; Upon thy banks, sweet Conway!'. However calm and still the fortifications of Conwy were in Prince's day, it was in sharp contrast to the preceding centuries of conflict, turmoil and violence.

Situated at the mouth of the river that shares its name and set against the verdant hues of the Carneddau mountains, the Conwy we recognise today owes its very existence to military conflict. For centuries the river had been a dividing line between tribes; an impenetrable natural fortification that armies struggled to cross save for a few easily defended points where there was great bloodshed for those who endeavoured. But in the spring of 1283, Plantagenet king Edward I (known as Edward Longshanks because of his height) achieved what most before him had failed to do: capture the west bank of the river. He displaced the only inhabitants – the peaceful monastic order of Aberconwy Abbey – and developed a fortified town to protect the newly established English colony within his recently conquered Welsh territory. Over the subsequent centuries, the stout stone walls of Conwy Castle witnessed many an attack by those wishing to see it destroyed. As the centuries passed, so did the castle's importance but later the wider town would play an integral part in two world wars. The first part of *Conwy's Military Heritage* examines the period from antiquity up to the nineteenth century. In the second part the emphasis centres on Conwy's involvement in military activity during the twentieth century up to the end of the Second World War.

Through the eons, language evolves, and no more so than with the spelling of Conwy. The river was known to the Romans as Canovium, having Latinised the ancient word for Cynwy meaning 'chief water'. To the Black Prince, great-grandson of Edward I, it was Conwei and during the turbulent times of Archbishop John Williams and the English Civil Wars, Conwai. Like his contemporaries, the aforementioned Victorian wordsmith John Critchley Prince wrote of Conway but in recent decades Conwy has become the standard form and, apart from where original sources are quoted or organisation names use the old spelling, is the version used throughout this volume. Since 1996, Conwy refers not only to the town but perhaps confusingly the local authority too; however, for the purposes of this book the geographical scope is the historic district of Conwy encompassing the outliers of Deganwy and Llandudno Junction with an occasional dalliance into the hinterland beyond.

1. Iron Age

Subsequent to the Bronze Age and prior to the Roman invasion of Wales in AD 48, a community constructed a hill fort at the summit of Conwy Mountain or Mynydd y Dref. With commanding vistas to the Creuddyn Peninsula, down the Conwy Valley to the lofty peaks of Eryri (Snowdonia) and across to Anglesey, it was the ideal location for a defensive position. There is still much debate as to who these Iron Age people were, and the exact time that they occupied the enclosure, but the most recent study estimates it was inhabited around 2,500 years ago. During the Iron Age there were two tribes in north Wales: the Deceangli and Ordovices. Some academics consider that the River Conwy was the westerly extent of the Deceangli community, whose territory extended east to the present-day English border, and the easterly boundary of the Ordovices, whose domain stretched across much of north-west Wales.

Hill forts, such as Caer Seion, were once thought to have been built solely for defensive purposes – the Iron Age Celts were believed to have been a ferocious bunch, easily drawn into battle on foot or horseback, but it now seems that the forts had additional functions that may signal a shift in the culture's values. Some were probably centres where families met on auspicious occasions, to celebrate rituals and for markets. It is clear that great time and resources were involved in building the hill forts. Of its type, Caer Seion is quite a small example, though at its peak of occupancy it may have been home to a couple of hundred people. It is not known whether the hilltop was lived on continuously, a temporary place of shelter for herdsmen, or for those who lived on the lower slopes and only retreated to the hill fort for refuge as circumstances dictated. Despite excavations

All that remains of the Iron Age fortified settlement Caer Seion, at the summit of Conwy Mountain.

there are few answers. Over fifty roundhouses stood within the 10-acre site. Many are double walled for insulation and some sit below the surface in an effort to keep out the pervading wind. Tree branches, turf, ferns and heather made up the thatched roof, supported by a central wooden post. Iron Age people certainly set out to make this stronghold unassailable. To the east a natural cliff formed a formidable obstacle for any attackers and embankments of stone and earth, 5 metres thick in places, surround the outer limits along with deep fosses (ditches).

The main access to the encampment was via a narrow entrance on the southern rampart, leading to a guard chamber where hundreds of sling stones – round beach pebbles – were discovered. Was this a hoard of ammunition ready to be used against attackers? Most warrior farmers of the Iron Age were armed only with slings and stones or an occasional iron-tipped lance. Nevertheless, the humble stone was a most effective weapon, especially when slung from an elevation. A proficient slinger was able to accurately hit a target at a couple of hundred metres range. Unusually for Welsh hill forts of this period, Caer Seion contained a fort within a fort, a small citadel within the main fortification that may have been constructed later in the Iron Age, most likely as a reaction to a threat, perhaps from another tribe.

Three archaeological examinations of the site have revealed little save a couple of spindle whorls (for spinning wool), a quern for grinding corn and a shapeless piece of iron. The people who dwelled here did not exist in isolation. Nearby on the Sychnant

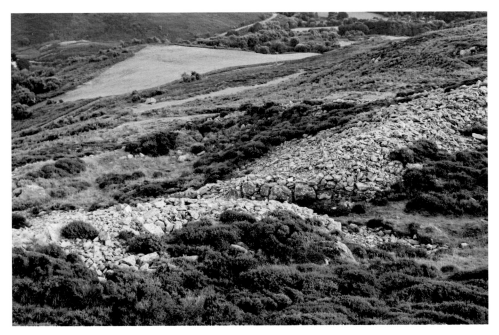

Having survived for more than two millennia, damage to the walls of Caer Seion was caused by soldiers of the Territorial Force (later the Territorial Army) when billeted at a nearby camp in 1909. They used the stone to build practice entrenchments until the council put the area out of bounds to the military.

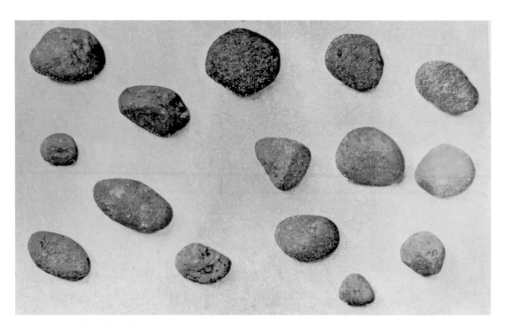

Slingshot pebbles found at Caer Seion after an excavation in 1906. These were found stored at the entrance of the fort in readiness to repel invaders.

Pass, a settlement of similar age, which includes the foundations of seven hut circles, has been found at Llyn Gwern Engan, while other forts occupied Pen Dinas above Llandudno and Pen y Gaer near Llanbedr-y-cennin in the Conwy Valley. One unanswered question is whether the people who occupied Caer Seion were connected to national markets as both producers and consumers. Some suggest that this was the case after a spindle whorl was unearthed in Conwy in 1965. The small flat stone with a hole through the centre was elaborately decorated with radiating grooves and a chequer pattern. Very different to other spindle whorls found in the locality, archaeologists believed that it was imported from elsewhere, possibly south-west England.

Although some academics have hypothesised about Caer Seion's occupation in later centuries, particularly by the Romans, the lack of archaeological evidence leaves these claims unsubstantiated. While Rome's forces under the command of Claudius reached the borders of Wales in AD 48, five years after they had begun their conquest of Britain, defeating some of the Welsh tribes proved troublesome. While the Deceangli yielded to Roman forces, the subjugation of the Ordovices took far longer and was completed by Julius Agricola in AD 77 and 78. Around this time, the Roman fort of Canovium at Caerhun was established, 5 miles to the south of Conwy, strategically placed at the crossing point of the River Conwy on the road from the major fort at Deva Victrix (Chester) to Segontium (Caernarfon). Initially built of earth and timber, this auxiliary fort was where 500 soldiers were garrisoned. Excavations in the 1920s revealed the size and layout of Canovium. Archaeologists uncovered numerous items such as coins, jewellery, pottery fragments, a cremation urn, a game with counters and a tile bearing the imprint of a child's foot. The stronghold continued to be occupied, irregularly, until the fourth century.

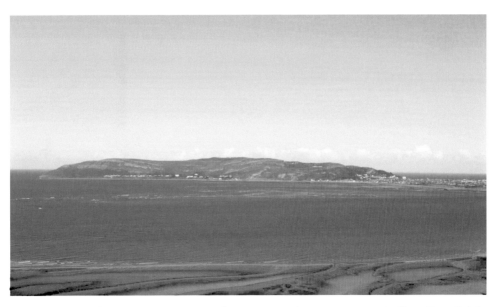

The Iron Age hill fort of Pen Dinas, across the estuary on the Great Orme, is in direct line of sight from Caer Seion. If both sites were occupied at the same time, were they friendly neighbours or raiding foes?

The church of St Mary's at Caerhun with its origins in the early medieval period. It stands on what was once the north-eastern corner of the Roman fort Canovium. The ramparts can be seen to the left of the place of worship. Initially the auxiliary fort was built of timber but later of stone, some of which was shipped from Cheshire.

2. Deganwy: The Establishment of the King of Gwynedd

With the departure of Roman authority, a power vacuum ensued throughout the land. Petty kingdoms developed, usually headed by a king who may have been a relatively high-ranking local under Roman governance. Some asserted their right to power by claims of descent from illustrious individuals such as Macsen Wledig – the founding father of several Welsh kingdoms. It was not long before raiding and warfare broke out between neighbouring groups while dynastic rivalry wrought conflict within families. As a result, the written records on which much of this history is based may be unreliable. Some were composed decades or even centuries after the events they recount and their creation may owe more to support for a contemporary faction or belief system than to accurate chronicling of people and events. They can also be at odds with the archaeological record. That said, the twin hills of the Vardre, Deganwy, are believed to have been a key site in this period. Finds including bronze coins from the time of Roman

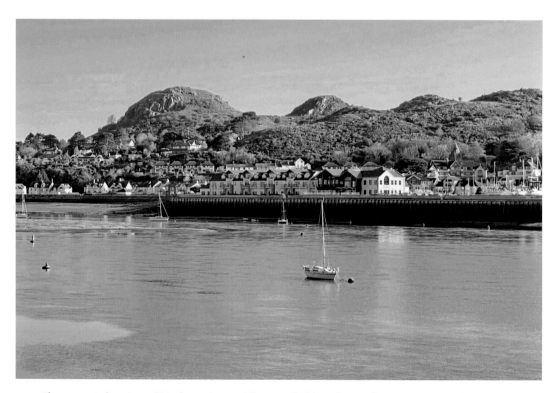

The strategic location of Maelgwn Gwynedd's stronghold on the Vardre, Deganwy, overlooking the River Conwy.

emperor Gallienus (260–268) to Valens (364–378), along with scraps of pottery, suggest that it was occupied as a Roman lookout against Irish raiders. A legend that stresses British unity (that is, of Celtic-speaking peoples, descendants of the pre-Roman tribes) was in place by 830. It tells of Cunedda Wledig, who came from the north during or soon after the late Roman period to expel the Irish from north Wales. He also founded the dynasty of Gwynedd. One of his alleged descendants was Maelgwn Gwynedd, whose court is assumed to have been sited on the Vardre. Excavation has revealed fragments of imported amphorae (storage jars) that once contained wine, indicating that Maelgwn's court had significant links with the wider world. This location probably continued as a royal residence up to 812, the year the Annales Cambriae tell us that it was burned to the ground by a lightning strike. It was presumably rebuilt, since it was again destroyed by fire in 822, but this time by the hand of Ceolwulf I of Mercia, the English kingdom to the east of the dyke constructed during the reign of King Offa. In earlier times Gwynedd and the Mercians had been allies, but, as is the nature of these things, they became acrimonious foes.

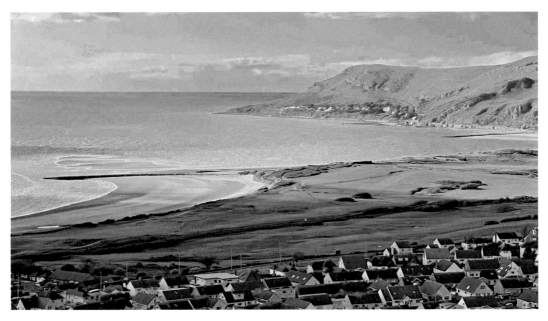

Beyond the houses and golf course in Deganwy is the Cerrig Duon sea defence groyne, which occupies the site of Castell Tremlyd. Destroyed by rising sea levels, Castell Tremlyd may have been a watchtower established by the Romans but was certainly used in the time of Maelgwn Gwynedd as the associated fish trap, curving into the channel, was known as Gorad Maelgwn – Maelgwn's Weir.

3. Rhodri's Revenge

In the mid-ninth century, Rhodri ap Merfyn succeeded his father as King of Gwynedd and within thirty years had annexed two further Welsh kingdoms, Powys and Deheubarth, to control great swathes of modern-day Wales. His energies were consumed in repelling attacks from both the Mercians and the Vikings. The Norsemen are recorded as having raided Anglesey in 853, with Rhodri defeating them three years later and during further skirmishes in 872. While adept at defeating the Scandinavians, Rhodri Fawr or Rhodri the Great, as he was now hailed, was slayed during a Mercian incursion by Ceolwulf II *c.* 878, after which Rhodri's eldest son, Anarawd, was enthroned Prince of Gwynedd. The remainder of Rhodri's land and titles were apportioned amongst his other sons.

Attacks against Celtic tribes was not limited to Wales. Fearing for their lives in Cumberland, northern Britons reached out to Anarawd, who granted them land between Conwy and Chester on the condition that they drove out the Mercians who had recently occupied it. They succeeded, but within three years, Æthelred, Lord of the Mercians,

The sleepy village of Aberffraw in south-west Anglesey. The royal palace of the kings and princes of Gwynedd is believed to lie under the modern-day houses of Maes Llewelyn.

advanced with a large force intent on regaining the lost territory. The northern Britons fled west over the River Conwy where Anarawd and his brothers raised a sizeable army and met the advancing Mercians at a bend in the river near the ancient township of Cymryd, a mile south of Conwy. The river at this point is relatively narrow and formerly could be crossed by stepping stones and a ford. Æthelred's men traversed the water but were ambushed by the Welshmen in the native woodland that once covered the riverbanks. Anarawd's troops put 15,000 of their enemy to the sword, avenging his father Rhodri Fawr's death, and reputedly turning the river red with blood. Defeated, Æthelred abandoned his attempts to subjugate the north Walians and instead turned his attention to the south.

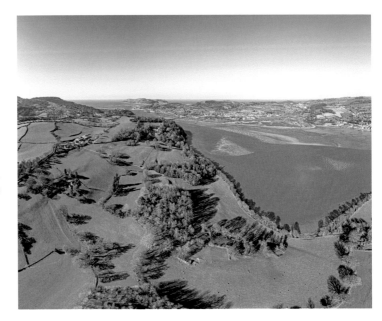

Aerial view looking north from Cymryd Point towards Conwy. In the foreground lies the battlefield where thousands of men armed with spears, axes and swords faced each other during the Battle of Conwy. (© GeoView Drones Ltd)

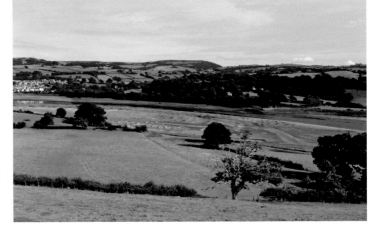

Cymryd Point looking towards Glan Conwy on the east bank of the River Conwy. The beauty and serenity today bely the carnage and slaughter that took place 1,200 years ago.

4. Deganwy: Welsh Princes and English Invaders

When Harold II of England defeated the combined forces of his brother Tostig and Norse King Hardrada at Stamford Bridge near York on 25 September 1066, Viking influence in Britain waned. It was to be replaced by an even greater threat when, nineteen days later, Harold lost the Battle of Hastings. The Normans had arrived on these shores and were soon making their presence felt in Wales. In Rhuddlan to the east, Robert, the deputy of Hugh d'Avranches, Norman Earl of Chester, raised a motte-and-bailey castle. At the same time, civil war was stirring for the throne of Gwynedd between Gruffudd ap Cynan and Trahaearn ap Caradog. Gruffudd was forced to retire to Ireland, later returning to Wales where he was captured and imprisoned by Hugh d'Avranches at Chester. He escaped and again fled to Ireland. All this gave Robert of Rhuddlan the chance to extend his domain towards the River Conwy where in 1080 he built a wooden castle on the now ancient site of the Vardre, Deganwy. Robert of Rhuddlan's successful career came to an abrupt

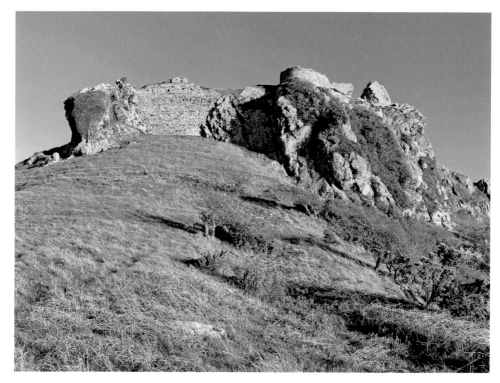

Deganwy Castle. The retaining wall on the left may date from Llywelyn's rebuilding of 1213. The round tower on the right is from the time of Henry III.

and brutal end in 1093 when he was slaughtered by Gruffudd on a Llandudno beach. The twelfth-century chronicles of Ordericus Vitalis tell us that Robert was enjoying a midday snooze when roused by sentries telling of the arrival of the Welsh. Summoning his soldiers to follow him down the precipitous slopes of the Vardre, they refused and the Norman nobleman found himself alone except for his man-at-arms. The Welsh attacked the two Frenchmen, spearing them to death, decapitating Robert and sailing away with his head fixed to the mast as a trophy. Robert's lands in Gwynedd were taken over by Hugh, but another Welsh revolt led by Gruffudd in 1094 resulted in the loss of most of the territory Robert had gained. Now in Welsh hands, the buildings on the Vardre were described as a 'noble structure' by Giraldus Cambrensis in 1191.

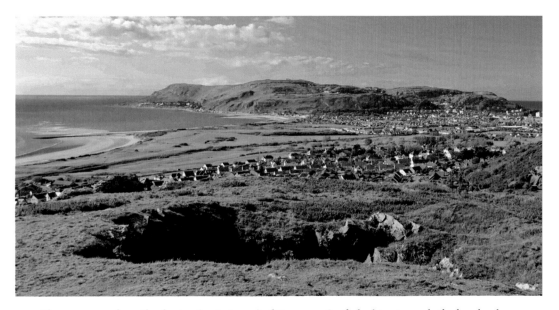

The panorama from the donjon (main tower) of Deganwy Castle looking towards the beach where Norman baron Robert of Rhuddlan was slain by Gruffudd ap Cynan. The quarry in the foreground supplied the stone used in the castle's construction.

5. Llywelyn Fawr and the Battle of Aberconwy

With many individuals vying for power, alliances were formed, though these were often fragile affairs. Welsh laws of succession necessitated that land was divided between the surviving sons and brothers of the deceased, rather than passing to a single heir. Rivalries and jealousies were rife. In 1194, a young and ambitious Llywelyn ap Iorwerth defeated his uncle Dafydd ab Owain Gwynedd at the Battle of Aberconwy to claim the title of Prince of Gwynedd, which he considered his rightful inheritance. Little is known of the Battle of Aberconwy except that it is said to have taken place on land situated just outside Conwy abutting the estuary, probably in the vicinity of the park now known as Bodlondeb.

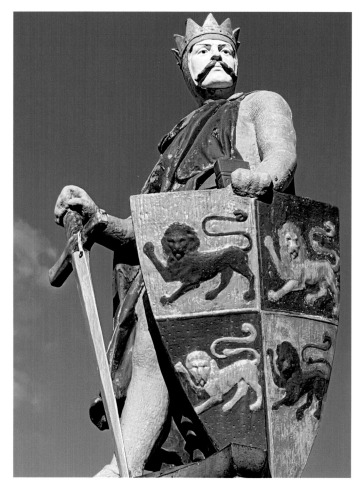

An effigy of Llywelyn Fawr surmounts the fountain in Conwy's Lancaster Square. The water feature was donated to the people of Conwy by Albert Wood, an industrialist living at Bodlondeb Hall just outside the town walls. The now colourful statue was unpainted until the 1950s.

In an epoch of turmoil when few ruled for long without being challenged, Llywelyn proved an astute diplomat as well as a courageous fighter during his forty-year reign. The relationship between Llywelyn and King John began cordially, with the Welshman making an oath of allegiance to the English monarch in 1201. By 1205 Llewelyn had married Joan, John's illegitimate daughter, thus cementing the alliance and giving him protection from the Marcher Lords who controlled the Welsh/English border. Matters quickly began to unravel, however, when Llywelyn extended his power into south Wales and four years after the marriage the forces of John moved towards Gwynedd. The noble structure at Deganwy was destroyed as part of a 'scorched-earth' policy and Llywelyn removed his forces and provisions across the estuary to Conwy. John occupied the abandoned site in 1211 and realised that he was left with inadequate supplies to continue the campaign, Llywelyn having removed every chicken, swine and sheep to the mountains. After being forced to eat their horses, John's hungry, vulnerable and dejected forces eventually abandoned the venture and withdrew to England. A castle of wood was subsequently erected on the Vardre by the Earl of Chester, which was captured by Llywelyn in 1213, who quickly set about rebuilding it. By 1216, Llywelyn was the most powerful ruler in Wales. King John died that year but Llywelyn's fight continued with his successor Henry III until they made peace in 1234. The truce was maintained until a crippled and wearied Llywelyn died at Aberconwy Abbey, Conwy, in 1240. Llywelyn had granted a charter to the Conwy monks in 1198 and took the monks' habit for the last few days of his life.

Henry's policy to subdue the Welsh was one of 'divide and conquer' and on Llywelyn's death he obstructed the accession of a successor. Inevitably this provoked conflict and in 1244 English forces again marched across north Wales. Dafydd, Llywelyn's legitimate

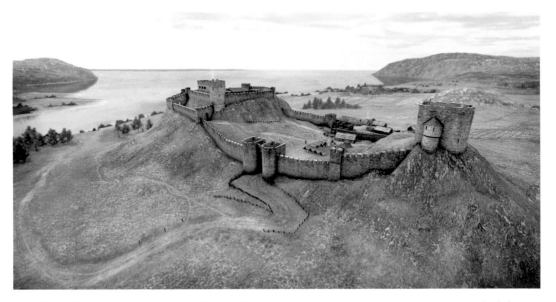

Three-dimensional impression of Henry III's once mighty fortress at Deganwy. Donjon on the left, Mansell's Tower on the right, curtain walls and gate between. (Courtesy of and © Martin Moss, Dextra Visual)

heir, did as his father had and destroyed the castle at Deganwy before fleeing across the river to Conwy. For a second time English forces huddled in tents, scavenging for food while the Welsh employed hit-and-run tactics. Much bloodshed was endured by both sides. The English began to rebuild the castle in readiness for Henry's visit in 1245 and by 1254 a substantial medieval fortification loomed above Deganwy, one of the most powerful royal strongholds in Wales. The notable remnants of masonry on the site date from this period. Henry issued a royal charter in 1252 that created a borough adjacent to the castle, but continuing raids by the Welsh culminated in the castle being besieged by Llywelyn ap Gruffydd (grandson of Llywelyn the Great) in 1257. The English-held castle fell and was destroyed by 1263. Henry recognised Llywelyn as overlord of Wales in the Treaty of Montgomery (1267). This was not to be the end of it, however. A battle-hardened general ascended the English throne in 1272: Edward I. Edward arrived at Deganwy in 1283 – and became another English king to camp on the Vardre – but seeing how easily the castle had fallen and recognising the strategic value of a riverside site where reinforcements and supplies could be delivered by sea, he founded his castle and town across the river at Conwy. Deganwy was abandoned. Welsh independence perished with the deaths of Llewelyn in 1282 and his brother Dafydd in 1283.

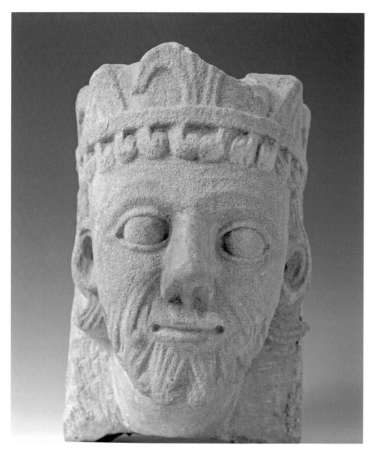

In 1965, a thirteenth-century carved stone head was discovered amongst the ruins of Deganwy Castle. Some believe it to be the face of Llywelyn ap Iorwerth (Llywelyn the Great) while others consider it to be that of Henry III. Both had a connection to Deganwy Castle. (By permission of Mostyn Estates Ltd)

Most historians believe that the battles between Llywelyn ap Grufydd (Llywelyn the Last) and Edward were fought away from the Conwy area but intriguingly fifteenth-century chroniclers Thomas de Walingham and Henry de Knyghton refer to a battle in 1282 that took place between the old Roman fort at Caerhun and Cymryd Point, where Anarawd had avenged the death of his father in 882. The confrontation was depicted in a painting by renowned nineteenth-century Conwy Valley artist Henry Measham called 'The Battle of the Fourteen Standards'. His work portrays Llywelyn and Edward engaged in personal combat on the banks of the Conwy, the Welsh encampment at Tal y bont in the background and features Porth Hywel Goch, the high wooded cliffs at Tal-y-cafn. The Welsh prince's *aides de camp* and three bards are represented as are numerous advancing Norman noblemen including Roger de Clifford. History tells us that Roger de Clifford was killed at the Battle of the Bridge of Boats, which was also fought between Llywelyn and Edward but on Anglesey.

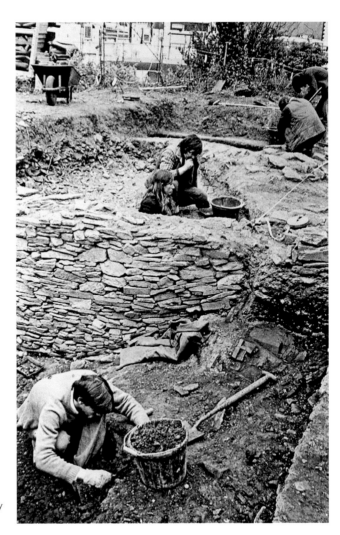

Archaeologists excavating Llywelyn Fawr's palace in May 1986. This medieval hall was built around 1198 and was probably where Llywelyn the Last signed the Treaty of Aberconwy with Edward I in 1277, effectively ending Welsh self-rule. Artefacts found include fragments of thirteenth-century pottery and animal bones, including Red Deer teeth. (Courtesy of Conwy Archives Service)

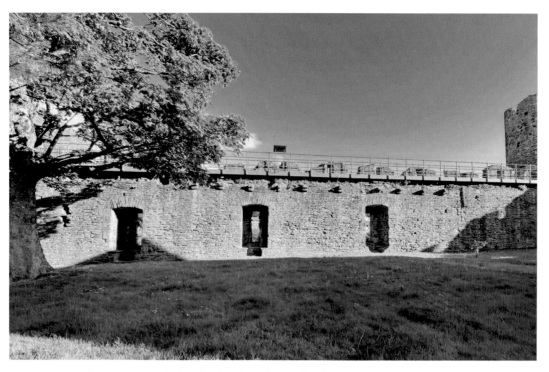

Following the excavation of Llywelyn's palace, the local authority erected a characterless housing complex for the elderly on the site called Tŵr Llewelyn and grassed the remainder.

6. Edward I and the Founding of Conwy Castle

From Edward's point of view, the decision to abandon Deganwy on the east bank of the river and build a fortification on the west bank proved a wise one. It enabled him to control the river crossing, land men and equipment at a newly built dock, the King's Quay and offered a secure base from which to launch strikes into Eyryi (Snowdonia) against the Welsh insurgents. When Edward arrived at Conwy there was already a small township dominated by the abbey, with its black-hooded, white-cloaked monks. They were moved to a new abbey at Maenan in the Conwy Valley and the monastery utilised by Edward as his temporary headquarters. The other structure that interested Edward was the remains of Caer Gyffin, a small fort purported to have been built by Maelgwn Gwynedd six centuries earlier. Some historians believe that the Plantagenet king constructed his magnificent edifice on the knoll where Caer Gyffin once stood. The decision to build was clearly pre-planned as within days a vast legion of engineers, masons and carpenters arrived ready to toil, along with the king's senior mason, Master James of St George, to supervise. Many of the labourers were drawn from Normandy. Conwy Castle was one of seventeen Edward had a hand in, creating an 'iron ring' of fortresses across Wales.

Construction began in spring 1283, the year after Llywelyn ap Gruffydd's death, with the eight towers and outer curtain walls of the castle built as a priority, in case of further attacks from Welshmen still loyal to Llywelyn. The architects and engineers engaged

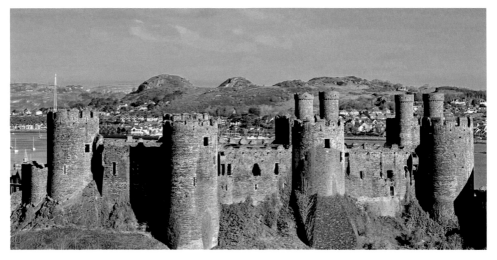

Conwy Castle from the south. The Vardre, the rounded hills beyond the river, was the site of Deganwy Castle – fought over for centuries by the Welsh and English – and was camped on by Edward I before building his fortress at Conwy.

by Edward were experts in defensive construction. Centuries of innovation, some of which had been brought back to northern Europe by returning soldiers of the Middle Eastern Crusades, ensured Conwy was at the zenith of castle design with a leap forward in defensive capabilities. The new fort took full advantage of its geographic position on a rocky outcrop with natural water courses on two sides and a dry ditch and wet moat dug around the remaining perimeter of the castle and town walls. This reduced the likelihood of tunnellers undermining the castle's foundations, as used to great effect by King John at the siege of Rochester Castle. Unlike the Norman's motte-and-bailey castles that were constructed largely of wood and thus easily burned by an archer's fire arrow, Edward's castles were built of stone extracted from local quarries. As the Romans had at Canovium 700 years earlier, sandstone was shipped from Cheshire for later embellishments and modifications. The stone edifice was a powerful statement, intended to dominate the landscape and leave no doubt to the indigenous population as to the English king's power.

Conwy Castle benefitted from round rather than square towers, which were more capable of deflecting shot from trebuchet while allowing a wider field of view for sentries. From walkways atop the battlements sentries patrolled. Snipers – armed with crossbows – could pick off the enemy with unerring accuracy firing from loopholes (flared openings in the castle walls). The crossbow had arrived on these shores with William the Conqueror, and while slower than a well-drilled archer, delivered a fatal skewer that traditional armour could not stop. The castle's drawbridge and portcullis abrogated the effectiveness of battering rams while machicolations, or 'murder holes', were installed

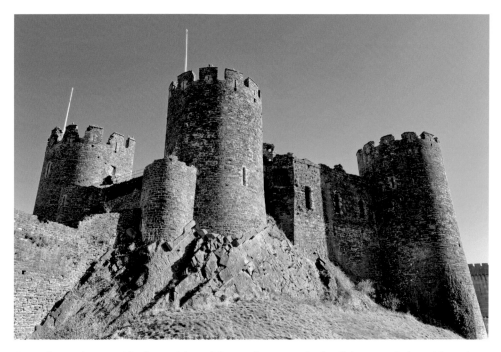

From the south-west side the position of the castle on a rocky knoll is most obvious. The prison tower is on the right, with the dungeon at its base.

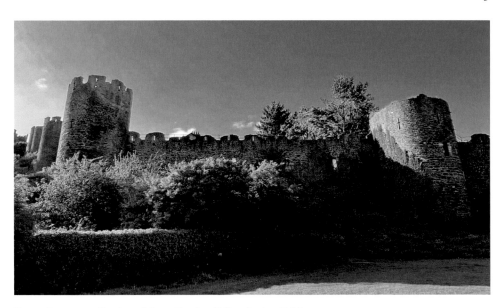

Conwy's town walls viewed from Porth y Felin playing fields.

through which defenders dropped rocks or burning objects. If the aggressors made it past those defences, the design of the castle meant they entered the barbican – a courtyard still outside the main castle walls and effectively an enclosed killing ground to trap the enemy. Within the main body of the castle, stout doors and secondary drawbridges hindered rapid advancement. The thought that went into the planning is illustrated by the inclusion of spiral staircases that wound to the right, disadvantaging the ascender with a shield on his left arm and a sword in his right hand. The walled citadel was covered by a timber-framed roof, originally covered with shingles but later replaced by slate and lead. The space was divided into outer and inner wards, the latter housing the king's palatial quarters and private chapel. To ensure self-sufficiency the castle had a bakery and brewhouse, and its own well fed by a natural spring. The outer ward contained the main kitchen and was the domain of soldiers, servants, courtiers and civil servants administering the affairs of Conwy town. Edward appointed the first constable of the castle in November 1284, commanding a garrison of thirty soldiers, of which half were crossbowmen. While a seemingly small force, the fortress could easily be defended from a far larger attacking army thanks to its cutting-edge, impregnable design.

Conwy's town walls were not an afterthought but an integral part of the plan. Construction started on the landward side soon after the castle's walls were completed and are replete with twenty-one towers and three twin-towered gatehouses, rendering them as formidable as most pre-Edwardian forts. Whilst today's visitor can walk unimpeded around the majority of the walls, Edward's architects left gaps that were bridged by wooden planks that could be removed quickly if threatened by assailants, effectively compartmenting areas of the walls. The 22 acres within the walls was a township solely for English settlers but was far larger than required, even taking into account land needed for agriculture. It was a synergetic relationship; the town provided for the castle's

needs while the fort protected the town's burgesses from the marauding Welsh. Fewer English settlers chose to make Conwy home than Edward had perhaps envisaged, partly because he acclaimed Caernarfon as the county town and centre of administration for the surrounding area rather than Conwy. With Caernarfon the centre of government and Beaumaris on Anglesey the trading port, an old saying went: 'The lawyers of Caernarvon, the merchands of Bewmares, the gentlemen of Conway'. The Welsh, who lived in isolated, scattered structures outside the sturdy stone barricade were only welcome within the town walls to sell their wares on certain days, a tradition that continues today with the seed and honey charter fairs in March and September respectively. Today there are many portals through the town walls, added by civil engineers over the last 200 years to expedite the passage of traffic, but originally there were only three entrances into the town. Porth Ucha was the only landward gate, leading to the Sychnant Pass. Protected by both a portcullis and drawbridge, it allowed access to the hinterland and Edward's castles to the west. Porth Isa opened onto the quay and was also safeguarded by an iron grating while Porth y Felin or mill gate led to the castle's saltwater mill at the mouth of the Gyffin stream. By the time the town walls were completed in 1287, King Edward had spent some £15,000 (approximately £11 million now) on his formidable fortress at Conwy and tens of thousands more on his other north Wales castles. It could be argued that the size and strength of Edward's castles are as much of a testimony to the resistance and temerity of the Welsh fighters whose tactics led Edward to having to build such defensive edifices.

Porth Ucha (Upper Gate) was the only landward entrance into Edward's walled town.

Conwy's defences received their first serious test in December 1294 when Madog ap Llywelyn, a distant relative of the now vanquished princes of Gwynedd, rebelled against Edward's rule, particularly the tax he was applying to his Welsh subjects to pay for the war in France. Madog did not act in isolation. While he attacked Edward's assets in the north, coordinated acts of insurrection took place in mid and south Wales at the same time. Foolishly, Edward had armed some Welshmen with the intention of leading them into battle at Gascony (France) but, galvanised by Madog's rhetoric, they used the weapons against him, capturing his castle at Denbigh and burning Caernarfon. A furious Edward arrived in north Wales to quell the revolt, forcing Madog's men to flee west along the coast. Edward, leading from the front, drove the Welsh towards Bangor but close to modern-day Penmaenmawr the natives ambushed him, forcing his retreat to Conwy's stout walls to await the rest of his army. The weather gods were not on the English monarch's side, however. He and his small retinue became trapped in the castle as the River Conwy entered full spate in January 1295. While Edward's army were camped on the east bank, the Welsh took full advantage, bombarding the castle for over a fortnight until the river subsided and reinforcements arrived commanded by the Earl of Warwick. The following year, Edward turned his attention north of the border, defeating the Scots at the Battle of Dunbar (1296) after they had signed a treaty with the French. In Conwy the castle was prepared in readiness to accept Scottish prisoners but there is no evidence of their detention.

By the fourteenth century, the castle had fallen into disrepair and the armoury was in such poor condition that the majority of weapons were unserviceable. Of greater concern to the monarch was the report that Conwy would be vulnerable if besieged. Under the Black Prince, the eldest son of King Edward III (1330–76), attempts were made to bring the castle back into good order and some repairs were instigated.

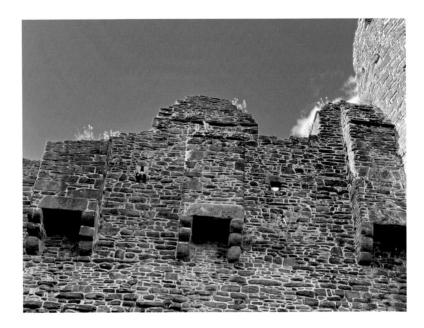

Garderobes (latrines) overhang the town walls; chutes took the waste to ground level.

7. The Betrayal of Richard II

In the late Middle Ages Conwy Castle was the setting for an event of great national significance. King Richard II ascended the throne in June 1377 on the death of his grandfather, Edward III. He was just ten years old. His reign was characterised by unpopular, repressive policies. Despite much acclaim in crushing the Peasant's Revolt in 1381, Richard's authoritarian approach continued and fearing trouble from discontented noblemen he executed some and exiled others including his cousin, Henry Bolingbroke. Richard also confiscated the vast majority of the Duchy of Lancaster estate, and divided it among his most loyal supporters, when Henry Bolingbroke's father died.

In 1399, Richard led an expedition to Ireland to reassert his authority. Henry Bolingbroke seized the opportunity to return from exile in France in order to claim his father's inheritance. Richard was in Dublin when he heard that banished Bolingbroke had landed in England but instead of returning quickly to suppress any revolt he dallied in Ireland and instead sent the Earl of Salisbury to raise an army of 40,000 men to fight for him when he arrived. After a fortnight of being held at a camp near Chester, the makeshift army, made up almost entirely of Welshmen, became restless and most deserted. Fearful that the king was dead and with little enthusiasm to go up against Bolingbroke and the powerful noblemen who were backing the renegade, they returned to their homes. Richard and a handful of supporters belatedly landed at Milford Haven, rode up through Wales and ensconced themselves at Conwy Castle where the Earl of Salisbury was waiting with the revelation of the deserting army, news not taken well by an increasingly fragile Richard.

The Earl of Salisbury advised his monarch to flee to the English possession of Aquitaine in south-west France where the king had been born, but by now Henry Bolingbroke had arrived at Chester and sent trusted aide, Henry Percy, Earl of Northumberland, as an emissary to Conwy Castle. The treacherous aristocrat did not travel alone and on reaching the outskirts of modern-day Colwyn Bay left a detachment of troops at Penmaen Head before proceeding to Conwy. Meeting in the castle's chapel and swearing an oath, Henry Percy assured King Richard that Henry Bolingbroke meant him no harm, had no designs on the throne but simply wished to have his grievances remedied and his status reinstated. After a meeting of his council, Richard accepted the accord and after Mass, Northumberland rode away.

King Richard and his small entourage left Conwy Castle and rode along the coast towards Rhuddlan Castle but while negotiating the headland at Penmaen Head they were surrounded by Northumberland's troops and, with no means of escape, taken captive. Again, the hapless monarch was assured that he would come to no harm. That evening, Richard was incarcerated at Flint Castle before his nemesis Henry Bolingbroke arrived to take him to Chester. Far from meaning him no ill harm, Henry Bolingbroke imprisoned Richard, secured his abdication and his own proclamation as King Henry IV. Richard was detained at the Lancastrian stronghold of Pontefract Castle, where he died in 1400.

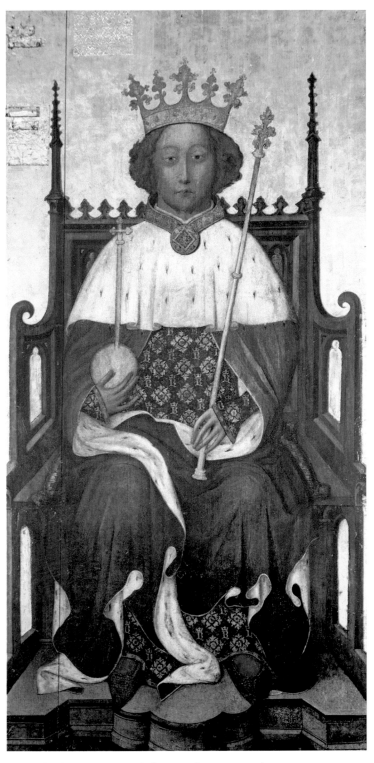

Portrait of King Richard II. (© Dean and Chapter of Westminster)

The limestone promontory at Penmaen Head where the ambuscade of King Richard II took place in 1399. Intensive quarrying in the nineteenth and twentieth centuries have completely changed how the landscape looked in the Middle Ages.

One Welshman who had fought under the English king, Richard, was his courtier Owain Glyndŵr of Glyndyfrdwy in the Dee Valley. Owain was descended paternally from the Princes of Powys and maternally from Llywelyn Fawr and the Princes of Gwynedd at Aberffraw. After the death of his father, Owain was fostered by the Anglo-Welsh judge Sir David Hanmer, and no doubt this influenced the young Owain to follow in Hanmer's footsteps and study law at the Inns of Court, Westminster. He later married Sir David's daughter, Margaret. In 1400, an English Lord, Baron Grey of Ruthin, seized part of Glyndŵr's estate in modern-day Denbighshire. The court case was dismissed and Owain Glyndŵr told: 'What care we for barefoot Welsh dogs'. Despite appeals to the new king to arbitrate in the dispute, Henry IV failed to do so fairly. This injustice was a catalyst for rebellion and Glyndŵr and his adherents attacked Ruthin, a market town in the Clwydian Hills. This quickly escalated into full-scale revolt, as many oppressed Welshmen saw the opportunity to express long-held grievances about English rule and the desire for a free, independent country. From across England, men returned to Wales to join Glyndŵr's fast-growing guerrilla army.

After the attack on Ruthin, the insurgency spread to other localities but a rapid, assertive response from the king's men appeared to quell the uprising. Many Welshmen involved in the revolt were pardoned. However, Henry IV raised taxes and issued a series of decrees against the Welsh and further unrest followed, spreading to Conwy at Easter 1401. On Good Friday, while the town's citizens and castle soldiers were at prayer at the garrison church of St Mary's, two of Owain Glyndŵr's staunchest rebels, his unpardoned

Engraving of Owain
Glyndŵr. (Courtesy of
Llyfrgell Genedlaethol
Cymru – The National
Library of Wales)

Anglesey cousins Gwilym and Rhys ap Tudur, entered Conwy Castle. Perhaps the timing was a coincidence, but this Welsh tactic of taking a castle, during a religious period, had occurred previously when Dafydd ap Gruffudd took Hawarden Castle on Palm Sunday in March 1282.

With the impregnable defences of Conwy Castle known to the Welshmen, the ap Tudur brothers simply bluffed their way in, fooling the sentries into believing they were a pair of humble carpenters ordered to work. After subduing the guards, they and their small militia of forty men took over the castle and burned the town, at the expense of the townspeople who were nearly all English. Gwilym and Rhys ap Tudur held the castle and town against the English forces of Henry 'Hotspur' Percy for nearly three months. Sir Henry Percy was the son of the treacherous Earl of Northumberland who had two years earlier acted as Henry Bolingbroke's envoy and visited King Richard at Conwy. The insurgents were eventually persuaded to surrender and, in the process, negotiated their own pardons but paid heavily. They were ordered to cede some of their own men to the English, who Hotspur allegedly had hanged, drawn, quartered and disembowelled to warn others against rebellion.

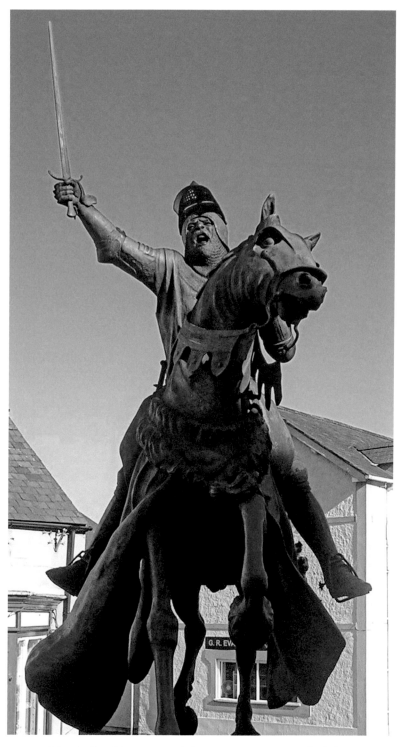

A life-size statue of Owain Glyndŵr was unveiled in 2007 at Corwen, Denbighshire – a stone's throw from his ancestral home at Glyndyfrdwy.

While the rebels' capture of Conwy was short-lived, it roused Welshmen to join an invigorated insurgency under the command of Owain Glyndŵr, who was proclaimed as Prince of Wales. Many supporting his insurrection were noblemen still loyal to the late Richard II and enemies of Henry IV. After Hotspur's withdrawal to Northumberland, Glyndŵr's army took over most of Wales and drew up a proposal, alongside the French, to overthrow the king and carve up Wales and a vast swathe of England between them. Over the next decade, a protracted and often bloody fight took place against the English under the command of Henry of Monmouth, who would later be crowned Henry V and victor at Agincourt. Henry finally quashed Welsh subordination after the recapture of Glyndŵr's stronghold, Harlech Castle, although the elusive rebel leader slipped away.

In the late sixteenth century, the upheaval and bloodshed gave way to more settled and prosperous times in Elizabethan Conwy. Nevertheless, there was concern that war may follow Francis Drake's exploits in entering Cadiz Harbour and 'singeing the King of Spain's beard', a reference to a series of attacks the privateer made against Spanish naval forces. The country was ill-prepared for any retaliation. It fell on the local gentry to raise, fund and equip battalions to fight if the need arose. For the Conwy area, this responsibility fell on the shoulders of John Wynn, whose seat was at Gwydir, near Llanrwst. His task onerous, how to turn agricultural workers, more used to scythe and mattock, to handle pike and musket? An ancient law decreed that every man, aged between sixteen and sixty, was liable for military service and on 21 December 1587 local men were ordered to gather at Conwy and told that they must hold themselves in readiness to serve at ten days' notice. This was reduced to an hour's notice in 1588, at the time of the Great Armada. As well as a shortage of capable soldiers, Conwy had no armoury and John Wynn sent his men to private houses to collect whatever they could. Beacons were prepared and coastal watches commenced but the danger passed and the men returned to the fields.

8. For King or Parliament?

It was also a period when one of Conwy's most beloved buildings was constructed: Plas Mawr, a townhouse on High Street. Another of the great houses built at that time was Parlwr Mawr on Chapel Street, the future home of John Williams, Archbishop of York and political advisor to King James I. He owed his amazing career to merit, indefatigable application and a limitless ambition, which carried him to the highest posts in the realm.

Plas Mawr, one of Britain's finest surviving Elizabethan townhouses, was built by Robert Wynn at great expense in the sixteenth century. Robert fought, and was injured in the leg, at the Siege of Boulogne in 1544 under the command of Henry VIII.

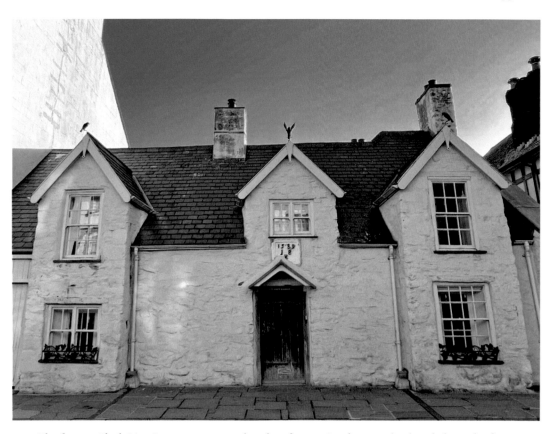

The former Black Lion Inn was presumed to date from 1589, the year displayed above the front door. However, recent research suggests that the timbers date back to when the town was rebuilt after Owain Glyndŵr's men sacked Conwy in 1401.

John Williams was born in 1582, the son of Edmund and Mary Williams, both of whom descended from eminent local families. John, it seems, was always destined for greatness as when just a boy of seven a family member stated: 'Jack is a very sharp lad, and he will become a famous man'. Displaying great academic aptitude, John was sent to Ruthin School and then attended St John's College, Cambridge. He studied hard and was blessed with a 'stupendous memory, clear judgement, keen common sense and untiring industry'. He was held in high esteem by the fellows of his college, particularly after successfully petitioning the king to increase the maintenance payments of the master and fellows. What followed was a meteoric rise in the court of King James I, first as Dean of Westminster, then as Keeper of the Great Seal (the last in a long line of clergymen to hold the highest judicial office) and later Bishop of Lincoln. After the death of King James, Bishop John Williams' fortunes fluctuated under the reign of the new monarch, Charles I. Williams had significant enemies at court and was falsely accused of treason, culminating with a hefty fine of £10,000, deprived of his benefices and, worse, imprisonment in the Tower of London. Following his release, he found himself back in favour, became an advisor to King Charles and in 1641 was awarded the Archbishopric of York.

The Elizabethan home of Archbishop John Williams, Parlwr Mawr. Despite efforts to save the historic building it was partially demolished after the Second World War. In 1950, the one standing wall suffered the ignominy of having the very first television aerial within the town walls placed on it. That wall was bulldozed in 1973 and with it a tangible link to Conwy's greatest son.

In the early 1640s, tensions between the Parliamentarian 'Roundheads' and King Charles' Royalist 'Cavaliers' were coming to a head over the manner of his governance and religious freedom. With increasing aggravation between the two sides, John Williams petitioned the king to leave York, and returned to north Wales to organise Royalist support in his native Conwy. Little had changed in his hometown since he had known it as a boy when Elizabeth I was queen, except that the castle had dilapidated further. At his own expense he paid for its overhaul and stockpiled weapons and provisions in readiness for a siege, while encouraging wealthy Royalist north Walians to entrust their valuables with him inside the castle. Williams had been promised the Governorship of Conwy Castle by the king, but instead, and despite protestations to Charles I, he was forcibly removed from the castle by Sir John Owen of Clenennau. Owen, a battle-hardened officer of the Royalist army and Sheriff of Caernarfonshire, arrived in Conwy at 'seven o'clock in the evening before the night guard was sent into the Castle' and 'did with bars of iron and armed men, break the locks and doors and enter the said castle'. Owen moved his own troops, including a battalion of Irishmen, into the castle. Appalled by the snub, Williams' conviction for the Royalist cause waned and, now living in Cochwillan, in Penrhyn, he switched allegiance to the Parliamentarians primarily to get his sworn enemy Sir John Owen removed from Conwy Castle and to regain the local gentry's treasures for which he was personally accountable.

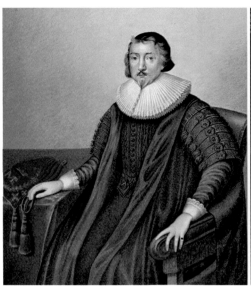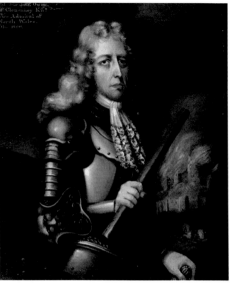

Bishop and knight: Archbishop John Williams (left) and Sir John Owen of Clenennau. (Courtesy of Llyfrgell Genedlaethol Cymru – The National Library of Wales)

By summer 1646, Parliamentarian forces, led in north Wales by Salopian general Thomas Mytton, had captured the castles at Chester, Chirk, Ruthin, Caernarfon, Rhuddlan and Denbigh from the Cavaliers and were laying siege to Conwy. Sir John Owen refused to surrender and one night in August, Mytton's army, aided by John Williams' insider knowledge, stormed the town – an attack that left Archbishop Williams slightly wounded in the neck. The red-uniformed Roundheads positioned their cannons on Twthill (Bodlondeb) and bombarded the town walls at the bottom of Town Ditch Road, giving the impression that the main assault would come from that direction. It was a feint and shortly after midnight, the raid came at Porth Ucha, Upper Gate, where the Parliamentarians scaled the walls and breached the gates. Mytton's men were very nearly foiled in surmounting the bulwarks, not by the Royalists, but from inadequate equipment. At 10 yards long, their ladders were too short and they resorted to scrambling over each other to overcome the shortfall. The Royalists, armed with muskets, pikes, halbards and long bills, were subdued in a few short hours and the town was taken along with some burghers and soldiers as prisoners. In a shameful incident, which is said to have shocked both Archbishop Williams and Sir John Owen, some of the Irish soldiers were bound back-to-back, by hand and foot, and thrown into the river. The intense bitterness against the Irish stemmed from the massacre in November 1641 of 5,000 Ulster Protestants and the death by starvation and exposure of many more. While Conwy town fell, the castle did not. Williams wrote repeatedly to Sir John appealing for him to surrender, but to no avail. Parliamentarian cannons positioned on Benarth Hill blasted the castle walls and the armed merchant vessel *Rebecca* on the river turned her guns on the castle. Parliamentarians were unable to walk around the town for fear of being picked off by Royalist snipers in the castle, and it was not until November 1646 that agreement was

reached allowing the Royalist soldiers to march out of the castle with their standards unfurled and bearing their swords, but not their muskets. The remaining Irish troops were allowed to leave unharmed. When cleared in later years, cannon balls from the Civil War period were found at the bottom of the castle's 90-foot-deep well. General Mytton faithfully fulfilled his obligation and returned to every individual, according to the clergyman's inventory, whatever had been entrusted to Archbishop Williams. After the archbishop's help in defeating Sir John Owen, Williams might reasonably have expected to be reappointed as constable of the castle but to his annoyance, Parliament awarded it to Colonel Philip Carter. Despite fighting on the side of the Parliamentarians, the Conwy man was still very much a Royalist at heart and was much grieved when King Charles lost his head, rising nightly at midnight to pray for fifteen minutes before returning to bed.

With Sir John Owen's surrender, 366 years of military conflict at Conwy Castle came to an end – the fortification had witnessed its last fight and the town besieged for the last time. In 1665, the Earl of Conwy stripped all that was valuable and the magnificent edifice was left as a ruin.

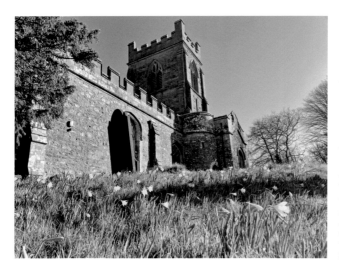

Archbishop John Williams died at Gloddaeth, near Llandudno (now St David's College), in 1650; it was his sixty-eighth birthday. He is buried at St Tegai Church, Llandygai near Bangor. His helmet and spurs were placed above his tomb. In 1956, the spurs were stolen and from the pulpit the Reverend Aelwyn Roberts appealed for their safe return.

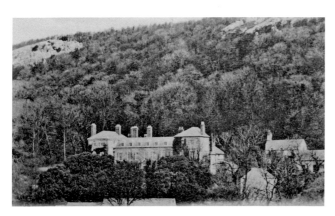

Marl Hall, near Llandudno Junction, was purchased by Bishop John Williams c. 1624, one of a large number of properties he owned. Marl's income was derived from revenues generated by the ferry which for centuries conveyed people and livestock across the River Conwy.

9. Napoleonic Wars

In the latter years of the eighteenth century, civil strife was prevalent across Britain and indeed Europe, resulting in the Corn Riots. While disturbances over the scarcity and price of food, particularly corn, were regular throughout the century, they took a more sinister turn between 1793 and 1801 when they threatened the internal peace. Conwy was not immune to these tumultuous times and documents held at Gwynedd Archives record that heavy fines were imposed on a number of individuals for rioting and carrying clubs. In March 1802, Britain and France signed the Treaty of Amiens following a decade of hostilities. It was a temporary peace as just over a year later, the two nations were once again at war after Britain became increasingly angered by the ambitions of French Emperor, Napoleon Bonaparte. Coastal fortifications were strengthened, including at Fort Belan near Caernarfon, which had initially been constructed during the American War of Independence. A new fortification was constructed at Holyhead, while a fire beacon was deployed atop the Great Orme. Proposals were also considered to incarcerate French prisoners at Conwy Castle, although this was not taken any further. While texts describe the castle as being near derelict at that time, there is evidence of soldiers of the Loyal Newborough Infantry Volunteers being garrisoned there from 1804. They were a disciplined and well-drilled unit, raised in 1799 by Thomas, Lord Newborough with headquarters at Fort Williamsburg in the grounds of his estate at Glynllifon Park, south-west of Caernarfon. Dressed in scarlet jackets with blue trim, white breeches and armed with muskets and pikes, they regularly attracted compliments from District Commander Major General Heron. As the Napoleonic Wars continued, small local militias and volunteer battalions were raised across north Wales, including the short-lived Loyal Conway Infantry Volunteers in 1803. Established and commanded by George Thomas Smith, the corps amalgamated six months later with other units to become the Bangor, Carnarvon and Conway Volunteers and in 1808 were re-badged as the Carnarvonshire Loyal Militia.

In the heart of Conwy stands the ancient parish church of St Mary. Built around 1284, on the site of the old abbey after Edward had moved the monks to the Conwy Valley, the churchyard is studded with memorials to departed denizens of the neighbourhood of the last two centuries. The association of Conwy with ships and the sea is unmistakable, with many headstones recording names of mariners, masters and captains while others allude to the local shipbuilding industry, ferrymen, pearl and mussel fishermen. One slate headstone records that Griffith Owen was a 'mariner of this port' and that he served during the Battle of Trafalgar of 1805.

Known to some as Griff Bach because of his diminutive height and to others as Griff y Saith Bol (Seven-Bellies Griff!), Griffith Owen was born near Amlwch, Anglesey, in 1779 and press ganged into service with the Royal Navy at a time of heightened French

Griffith Owen's headstone at St Mary's churchyard.

belligerence. Although compelled into service, Griff had money deducted from his pay for his hammock and uniform. The rest he spent on tobacco and sent home to his mother. In February 1797, he was involved at the Battle of Cape St Vincent in which the Spanish triple-decker gunship *Salvador del Mundo* was dismasted and captured by the Royal Navy. At Trafalgar, Ordinary Seaman Owen was aboard HMS *Conqueror*, a seventy-four-gunship under the command of Captain Israel Pellew, helping Lord Horatio Nelson's Royal Navy defeat Admiral Villeneuve's Franco-Spanish fleet, despite the enemy's superior number of ships. During the fierce five-hour battle, three men were killed and nine wounded on HMS *Conqueror* as she engaged the French flagship *Bucentaure* and the Spanish gunship *Santissima Trinidad*. The rout of the combined French/Spanish armada effectively ended Napoleon Bonaparte's ambitions of invading Britain as naval superiority to cross the English Channel could not be guaranteed. For his service at Trafalgar, Griffith received a bounty of £2 and 10 shillings, and by the end of the decade was promoted to Able Seaman. He remained with the Royal Navy and HMS *Namur* until discharged in 1815 when he came to Conwy, living at Chapel Street, and selling fruit and vegetables from a cabin near the railway station. A notice at the stall told of his service under the Commander-in-Chief of the Mediterranean fleet, the late Admiral Nelson, which guaranteed plenty of custom by a public that had bought into Nelson's legendary status. Griff died in 1860 but his memory lived on with local children decorating his grave with autumn foliage and hedgerow fruits annually on Trafalgar Day, 21 October. This tradition continued into the latter half of the twentieth century – some 100 years after Griffith Owen's death.

Close to Griffith Owen's grave is the last resting place of Private Thomas Foulkes. Two years after the Battle of Trafalgar, Napoleon Bonaparte's French army invaded Spain and Portugal, deposing the monarchy and installing his brother, Joseph, on the Spanish throne. Most Spaniards opposed the occupation and along with Portuguese and British forces, commanded by Sir Arthur Wellesley (later the Duke of Wellington), fought a series of battles to oust the French. The turning point in the conflict came when

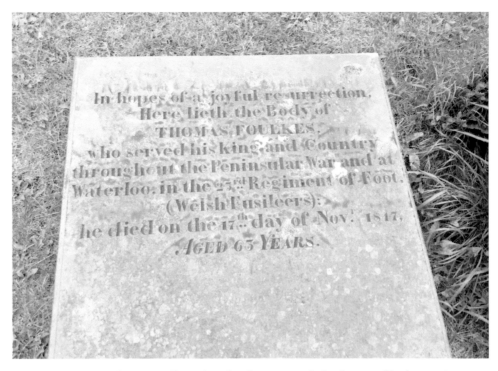

The grave of Private Thomas Foulkes, whose headstone records that he served his king and country throughout the Peninsular War and at Waterloo.

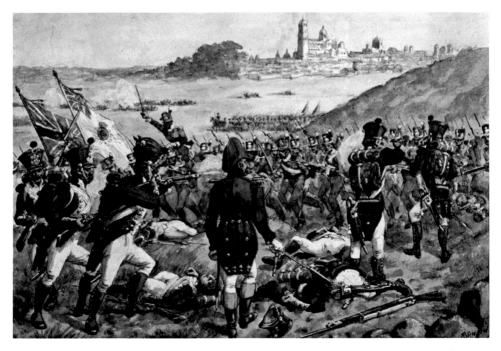

An Anglo-Portuguese army under Sir Arthur Wellesley defeated Marshal Marmont's French forces in the hills around Arapiles, south of Salamanca, Spain. (Richard Simkin 1850–1926)

Napoleon committed divisions of his army to invade Russia, leaving Spain woefully under-defended. Lieutenant General Wellesley and his allied army pushed into Spain and forced the French to flee across the Pyrenees. Serving with the 23rd Foot, the Royal Welch Fusiliers, Conwy soldier Thomas Foulkes fought on the Iberian Peninsula for six years between 1808 and 1814, seeing action at Corunna, Albuera, Ciudad Rodrigo, Badajoz, Salamanca, Vittoria and Nive. Foulkes survived this prolonged campaign and in 1815 served at the Battle of Waterloo near Brussels, where the armies of Britain and Prussia defeated the forces of the French Republic, compelling dictator Napoleon Bonaparte to surrender. The final defeat of Napoleon in 1815 ensured a long period of peace in Europe. Thomas Foulkes returned to Conwy and lived in the High Street with his wife Ellin, dying in November 1847 aged sixty-three years.

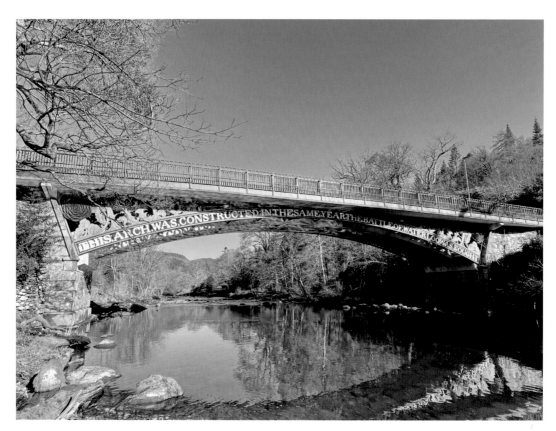

The bridge at Betws y Coed is a memorial to the British victory at Waterloo that ended over two decades of continuous fighting with France. Although it states 'This arch was constructed in the same year the Battle of Waterloo was fought', it is a little misleading as the bridge was constructed the following year.

10. Conwy Morfa Camp

In the mid-nineteenth century, an area of windswept marshland outside the town walls was utilised as a temporary camp for the Volunteer Force, a part-time citizen army. Rudimentary at the outset, Conway Corporation encouraged the camp's development to bring much needed trade to the town and over the next fifty years it was improved greatly, eventually boasting its own water supply, sanitary arrangements and rifle range. In 1895 a railway station, Conway Marsh, was constructed specifically for the camp.

After the far-reaching reforms suggested in the 1904 'Esher Report', the army was reorganised, reducing three echelons of land forces to two and the Volunteer Force formed part of the new Territorial Force. This change did not affect Conwy Morfa Camp and battalions of soldiers from across Wales and the north of England arrived for their annual two-week training camp. On the day the First World War was declared, 4 August 1914, thousands of men of the York and Durham Brigade were at Conwy Morfa camp. Over 5,000 troops hastily packed up their belongings and, with 400 horses, boarded eight special trains to take them back to depots in north-east England. When it became apparent that the First World War 'would not be over by Christmas', 1914, the government proposed that the Conwy camp should be converted into a permanent military encampment, with wooden huts replacing canvas tents. Ablution blocks and kitchens were built, as was a drill square and parade ground.

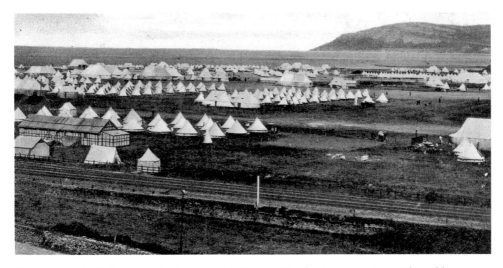

Five or more battalions regularly camped at Conwy Morfa at any one time. The soldiers were billeted in canvas bell tents and while conditions were basic the correspondent who sent this postcard in 1902 certainly enjoyed the fishing, having netted twelve fish the previous day.

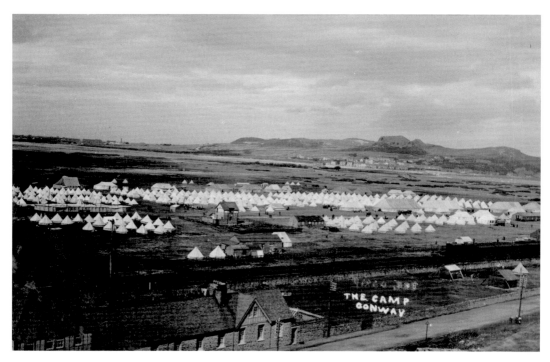

Looking across Conwy Morfa Camp towards Deganwy. The brick building in the foreground was the Hadley Home built by Felix Hadley for employees of his Birmingham nail manufacturing plant. During the First World War, it was a billet for members of the WAAC – Women's Auxiliary Army Corps. After the Second World War it was a bakery where Welsh Home Loaf and Champion breads were produced.

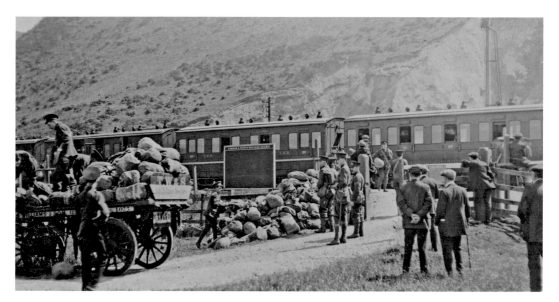

Soldiers of the Lancashire Fusiliers disembarking from the train in readiness for their annual fortnight at Conwy Morfa Camp in 1912.

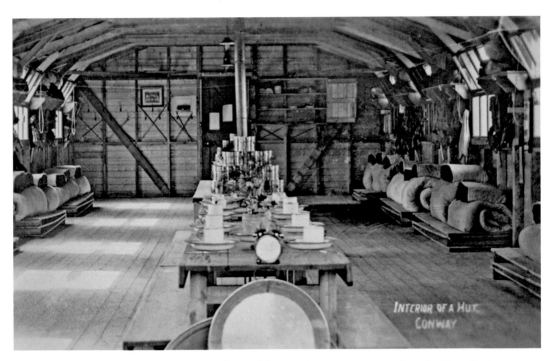

Huts usually accommodated twenty-four soldiers and one non-commissioned officer. Each was heated by a single pot belly stove and the men ate at a central table. Each man's belongings and webbing were neatly stowed above their bed rolls.

The first troops to occupy the new permanent camp were the 15th and 16th Battalions of the Lancashire Fusiliers, known as the 1st and 2nd Salford Pals. They were raised mainly from poor, slum areas of Lancashire and in all some 2,000 Salford men were billeted at Conwy in summer 1915. They were followed by men of the Border Regiment and then Royal Engineers who spent time training, drilling and shooting on the many acres of this sea front encampment.

Within ten days of the declaration of war, the YMCA had established over 250 recreation centres at army camps around the UK. They usually provided no more than a cup of tea and some reading material, however at Conwy, a piano and billiard table were installed. Recreation rooms were also set up in Conwy for the troops billeted at Morfa camp. These were for quiet pursuits including letter writing, playing cards and board games. Conwy's public houses did a roaring trade but after a series of incidents the council brought in new rules that ordered licensed premises to close at 9 p.m. – this was not popular with the locals. Women were not allowed in public houses after 6 p.m.

In the interwar years, the military's lease expired and the Holiday Fellowship took over the site but at the outbreak of the Second World War it was again requisitioned by the government. In 1940, soldiers of the British Expeditionary Force were billeted at Conwy Morfa after their evacuation from Dunkirk. Later the Royal Netherlands Army moved in. This regiment was made up of Dutchmen who had escaped their homeland after it fell to Germany in May 1940 and Dutch civilians living in Britain who wanted to

enlist in the army of their birthland. The Koninklijke Landmacht were extremely popular in Conwy, not least because of the dances that they organised at the Town Hall every Tuesday evening. Tickets were much sought-after especially among the local single ladies. The Hollanders left Conwy in 1943 for further training and later played a pivotal role in *Operation Overlord* – the Allied invasion of Normandy.

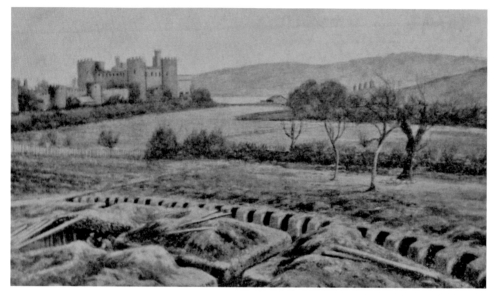

Above and Below: Troops dug practice trenches both around Conwy town, particularly at Maes y porth gardens (above) and on Conwy Mountain (below) where today the faint outline can still be seen over a century later.

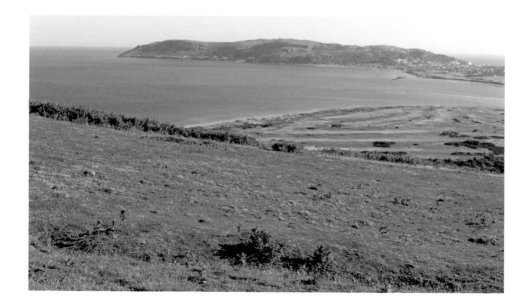

Royal Engineers officer cadets outside a bell tent at Conwy Morfa Camp. (Courtesy of Mervyn Wynne Jones)

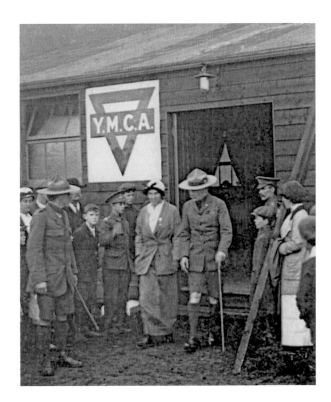

Lord Baden Powell, founder of the Scout movement, opened the YMCA (Young Men's Christian Association) hut at the Morfa Camp in March 1915.

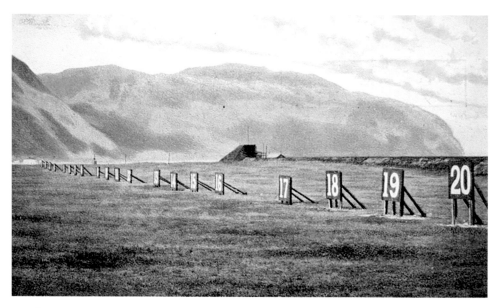

Royal Engineers constructed a gallery with twenty targets for musketry practice, allowing up to 4,000 men to pass through the musketry course without 'undue hurry and in a limited time'. When these targets were installed in 1900, they had a telephone link between the firing point and the gallery. The work was paid for via a loan by Conway Town Council at a cost of £1,250.

Not every soldier at the Morfa rifle range was a crack shot. Fishermen complained that soldiers were missing the targets and that they were in danger as they sailed past. To alleviate the problem, sentries were posted at either end of the butts to keep watch for fishing boats and warn the riflemen.

In August 1946, the buildings at Conwy Morfa were utilised as a Polish Resettlement Camp and temporarily housed 368 men, women and children who could not, or did not want to return to Poland after the war in Europe. The transit camp was a satellite of the main camp at Tŷ Croes, Anglesey. As well as Polish civilians, there was a contingent of sixty-five Polish officers and men of the Second Polish Corps who had seen fierce fighting during the Italian campaign of 1944. Amongst the Polish soldiers who came to Conwy was Bruno Bitowski. Although he spoke no English or Welsh, Bruno found employment with a local logger, felling trees and selling the firewood. At weekends, dressed in his Polish army uniform, he attended dances in St Michael's Church hall where he met Ann Owen, a local girl who had served as a nurse with the Voluntary Aid Detachment during the war. They married in 1950. The Polish Resettlement Camp closed in 1947 and Conway Borough Council requested that the Morfa be 'de-requisitioned'. Later that year twenty-four prefabricated houses were erected to ease the post-war housing shortage.

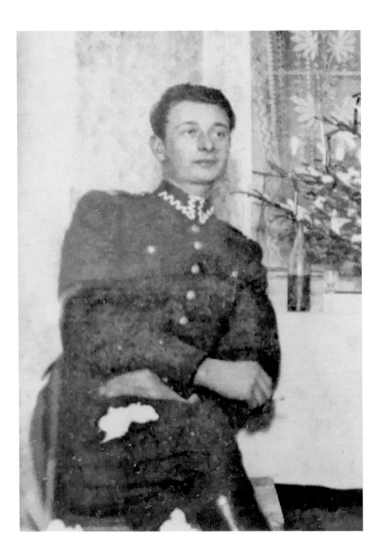

Bruno Bitowski.
(Courtesy of Anna
Bitowski)

Today the area of Conwy Morfa Camp is still used by campers, albeit the surroundings and conditions are far more luxurious than when the army camp was built over 150 years ago.

11. Deganwy Camp

In March 1915, on the opposite side of the river to the camp at Morfa, another smaller campground used by the Territorial Force was readied to billet a newly formed battalion of the Royal Welsh Fusiliers. When war broke out in 1914, millions of men rushed to volunteer, but some of those keen young men, fit and ready to fight, were turned away – for being too short. The height requirement for recruits to the British Army was 5 feet 3 inches tall with a chest measurement of at least 34 inches. It soon became apparent that this rule excluded many men who were otherwise perfectly fit to serve and desperate to 'do their bit'. As a consequence, 'bantam battalions' were formed for diminutive recruits including the 19th Battalion, Royal Welsh Fusiliers, at Deganwy. Soldiers were billeted in private houses at Deganwy and Llandudno Junction with landladies receiving 3 shillings 4½ pence per soldier per day – a shilling and a penny more than landladies in neighbouring Llandudno were getting! In return, householders provided a mattress on the floor, where soldiers slept five or six to a room. They also fed their guests, with the army stipulating that the fare must be 'good, sufficient and wholesome'.

As at Conwy Morfa, members of the Territorial Forces had camped at Deganwy since the late nineteenth century. Known originally as Ffrith Gerrig Camp, the weather wasn't always conducive to open-air living and a storm wreaked havoc to the bell tents in 1911.

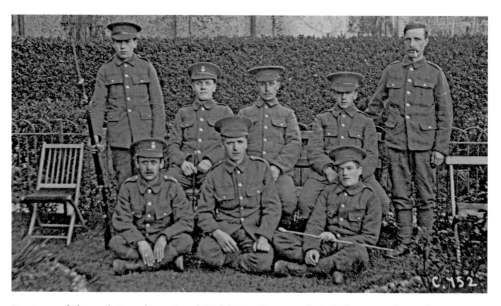

Bantams of the 19th Battalion, Royal Welsh Fusiliers, at their billet in York Road, Deganwy. (Courtesy of Home Front Museum)

There was scandal in April 1915 when in the House of Commons, the Under Secretary of State for War was asked if bantam soldiers of the Royal Welsh Fusiliers were being quartered in the home of a German national at Deganwy. Red-faced officials admitted that they had placed soldiers in the house of an 'alien' and the soldiers were immediately removed from Bryn Awel on York Road, much to the disappointment of owner Frau Braun. While Mrs Brown had been born in Germany she left when aged twenty, settling first in America before marrying and moving to Deganwy in 1907. She admitted to a local newspaper that while her brother was in the German army, she thought herself as English and had even been knitting woollen comforts for British troops on the frontline. The Bantams left Deganwy in July 1915 for a camp in Shropshire. Large crowds of well-wishers, particularly young ladies, lined the streets and the band of the London Welsh battalion, billeted at nearby Llandudno, played patriotic tunes. As the men boarded the train, each was presented with a box of cigarettes while a small white goat was presented to the battalion by the inhabitants of the village.

No sooner had the Royal Welsh Fusiliers left, the Royal Engineers arrived and established a training centre. The Engineers dug hundreds of yards of practice trenches in the area, particularly on land that is today Maesdu Golf Club and behind the village on the Vardre. In very dry conditions, the outline of the trenches can still be seen in the fairways and on the greens. There was much interest locally when the Royal Engineers announced that they were going to bridge the River Conwy from Deganwy promenade to the Beacons – the narrowest but also fastest part of the river. While small timber and rope suspension bridges were built in the sand dunes there is no evidence that an attempt was made to span the river. However, they did rope together a flotilla of small dinghies to create a pontoon across the river.

Don't be Alarmed,
the Royal Engineers are on
guard at Llandudno Junction

Royal Engineers arrived in Deganwy and Llandudno Junction shortly after the Royal Welsh Fusiliers left in the summer of 1915.

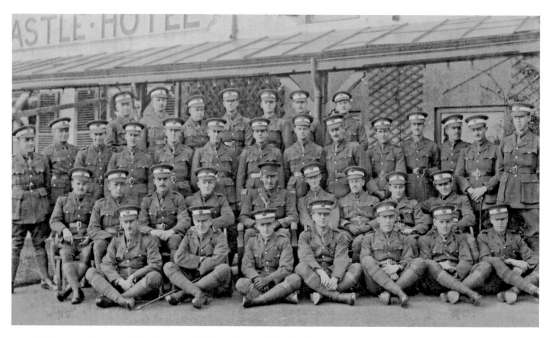

Officer cadets outside Deganwy's Castle Hotel, which was requisitioned as part of the Royal Engineer Training Centre. (Courtesy of Karlyn Goulbourn)

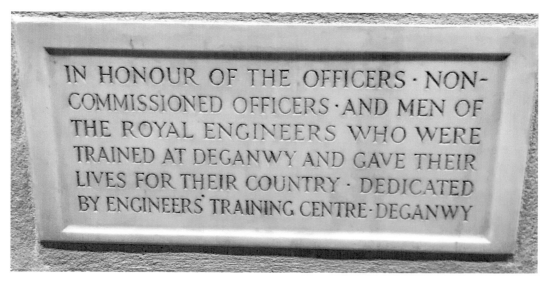

A memorial plaque dedicated to the officers, non-commissioned officers and men who passed through the Royal Engineers Training Centre at Deganwy now hangs at the Union Jack Club, central London.

12. Cae Coch Sulphur Mine

Between Dolgarrog and Trefriw is an abandoned mine that played a vital role during the First World War. The term 'Canary Girl' refers to female munition workers whose skin turned yellow after handling explosives when filling shells in munition factories. This was primarily TNT, which contained sulphur, some of which was mined at Cae Coch. Although believed to have been worked since Roman times, the height of production at Cae Coch was in the nineteenth century when a succession of owners extracted thousands of tons of the mineral, which was shipped to Liverpool for processing.

By the beginning of the twentieth century, mining had all but ceased at Cae Coch but with the threat of a European war mines across the country were surveyed and estimates of raw materials made to determine the viability of reopening. It was decided that reopening Cae Coch would not be viable but as the First World War dragged on and sulphur became increasingly difficult to import from abroad, Cae Coch was requisitioned by the Ministry of Munitions. By mid-1917, a workforce of over 200 men resumed mining and in the second six months of 1918 alone removed nearly 16,000 tons of sulphur rich stone, which was loaded onto trains on the east side of the Conwy valley via an aerial ropeway. This equated to 50 per cent of all sulphur output from British mines during that period.

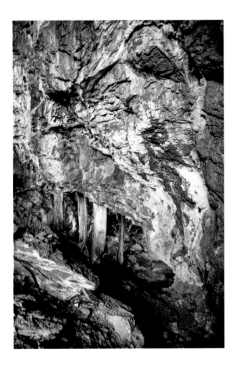

Vivid hues of colour at the Cae Coch sulphur mine.

13. The Second World War

On 1 September 1939, Germany invaded Poland. Despite the British and French governments giving Adolf Hitler an ultimatum for his troops to leave Poland, he refused. On the morning of 3 September, a final letter to withdraw was sent to the German leader. When these demands continued to be ignored, Prime Minister Neville Chamberlain promised that Britain would 'fulfil its obligations to Poland', committing the country to a second European war in a generation.

The day that Germany occupied Poland, a blackout was introduced across Britain requiring all light from houses, shops and businesses to be concealed. There was a rush to buy blackout material from local stores and thick brown paper from R. E. Jones Ltd, printers of the *North Wales Weekly News*. Street lamps were turned off and in the first month of the war, road traffic accidents trebled. Measures were introduced to reduce casualties on the road with white lines painted on kerbs, bollards and trees by council workmen.

In October 1939, news came of Conwy's first casualty of the war. The victim wasn't a soldier, sailor or airman but septuagenarian William Roberts, killed by a Llandudno-bound bus as he made his way home to Plas Iolyn Park during the blackout.

It was the duty of air-raid wardens to check properties for blackout coverage, which they did with some zeal, and in the early months of the war Conwy Police Court was inundated with cases. The first was in October 1939 when Myfanwy Roberts of the Korner Café in Lancaster Square was fined £2 for 'showing a light'. Policing the blackout was not the only duty of the 200 air-raid wardens in the district. Their responsibilities were wide-ranging and included sounding the air-raid siren, guiding people into public air-raid shelters and issuing gas masks. Weeks before the outbreak of war over 8,500 gas masks had been

Poster exhorting residents of Llandudno Junction to enlist into the Civil Defence service. (Courtesy of Home Front Museum)

BOROUGH OF CONWAY

NATIONAL SERVICE—

AIR RAIDS PRECAUTIONS

PUBLIC MEETING

A MEETING will be held at the Council School, Broad Street, Llandudno Junction, on TUESDAY, THE 9th MAY, 1939, for the purpose of stimulating the enrolment of Volunteers in the Llandudno Junction Area for Air Raids Precautions work.

The Chair will be taken by His Worship the MAYOR OF CONWAY (Alderman E. D. Rowlands, J.P.)

The Meeting will commence at 7.30 p.m., and the Public are earnestly requested to attend.

At the termination of the Meeting applications for Enrolment as Air Raid Wardens, etc., will be received.

R. E. Jones & Bros., Ltd., Printers, Conway.

distributed to the civilian population of Conwy district. On billboards, posters reminded the public to carry their gas mask at all times and wardens reproached those seen in public without them. As the war dragged on, fewer and fewer people bothered and in April 1941, to mark the start of the new bowling season, Conwy Bowling Club announced a novel competition – bowling in gas masks! It was suggested that this would encourage members and players to continue to carry their gas masks and the event drew a large number of curious spectators. For reference Mr J. Rigby beat Mr F. Groom in the final. The Caernarfonshire County gas van regularly visited the council offices at Bodlondeb where members of the public were invited to test their gas masks. In July 1941, 400 brave residents donned their respirators and with some trepidation walked through the tear gas-filled chamber to test the effectiveness of their masks. All functioned commendably.

While Conwy escaped the sustained bombing raids that other towns and cities suffered, there was one incident of note. In March 1941, Conwy's air-raid sirens sounded and a message was received in the civil defence control room located below the council chamber at Bodlondeb indicating that bombs had fallen in the locality. The German ordnance had struck and badly damaged a house on the outskirts of the town known as Bryn Morfa. The elderly owner was conveyed to hospital suffering from shock and minor injuries. Evidently Jane Hughes' injuries might have been significantly worse had she not decided to read her bible a little longer and retired upstairs at the normal time. As an aside, during the Cold War the cellars at Bodlondeb were converted into a nuclear shelter complete with concrete blast doors on the entrance, a ventilation system, water storage, toilet and twenty-four bunk beds.

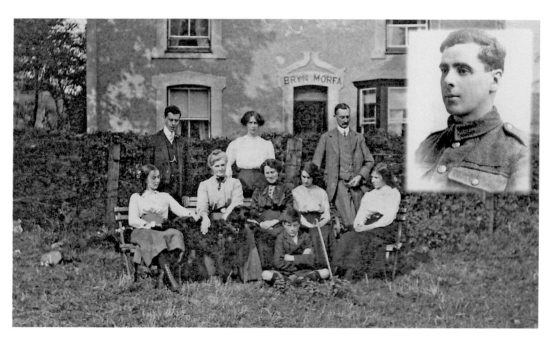

The Hughes family at Bryn Morfa, c. 1915. Thomas and Jane Hughes' son Hugh (inset) died of influenza in November 1918, just ten days before the Armistice. (Courtesy of Nancy Hess)

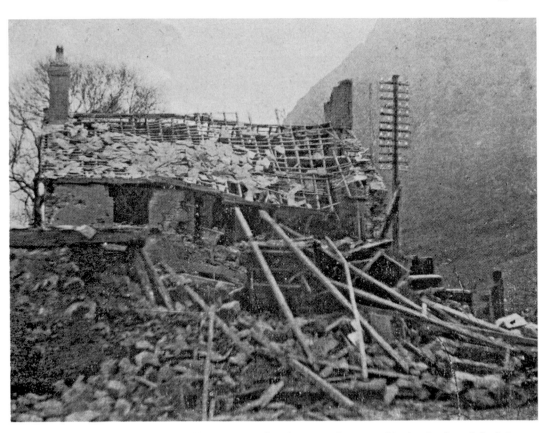

Bryn Morfa was badly damaged by a German bomb in March 1941 and had to be demolished. It was later rebuilt and today is central to a caravan park of the same name. (Courtesy of Mervyn Wynne Jones)

14. Evacuation

In January 1939, with war looking increasingly likely, the government prepared to relocate children and vulnerable people away from densely populated urban areas. With news that Conwy was classed as a reception area for evacuated people, a meeting was convened at the Guildhall to prepare for an influx of refugees. A survey of residents ascertained that accommodation could be found for 5,900 people including 3,943 children. On 2 September 1939, the day before Neville Chamberlain declared war, cars mounted with loudspeakers toured the district announcing that evacuated children should be expected the following day. The broadcast also reminded householders that should they fail to accept the evacuees they would be committing an offence and prosecution might follow. Most of the children who arrived in the Conwy district came from the Shiel Road area of Liverpool. They attended either Boaler Road, Newsham Boys or St Cuthbert's Roman Catholic schools in the city. Amongst the children to come to Llandudno Junction from Merseyside was nine-year-old Peter Adamson. He was billeted, along with his brother Clifford, with Mrs Marie Evans at Ronald Avenue and in later life found fame playing the role of Len Fairclough in television soap opera *Coronation Street*. In total 1,090 children and 248 adults were received in Conwy, Deganwy and Llandudno Junction in September 1939, far fewer than was originally expected.

It was not just people that were relocated to Conwy during the war but also valuable paintings. In 1941, thirty-two important works of art from Birkenhead's Williamson Art Gallery were transferred to local municipal buildings for safekeeping. These included works by Sir David Young Cameron, John Constable and Thomas Gainsborough. Two watercolours by J. M. W. Turner, *Vesuvius Angry* and *Brenver Glacier*, graced the walls of the Sanitary Inspector's office while a further three oil paintings by Arthur Friedenson, Mark Fisher and E. A. Hornel adorned the council chamber at the Guildhall. The pictures were returned to the Williamson in December 1946, but such were their popularity that they lent Conwy a further tranche of paintings, many of north Wales interest, which were displayed at Bodlondeb. While refugees and paintings came to Conwy, members of Conwy's Auxiliary Fire Service went the other way and helped beleaguered and overworked fire services put out blazes, particularly in Wallasey during the May blitz of 1941.

BOROUGH OF CONWAY

TELEPHONE 207

MAYOR
Councillor E. D. Rowlands,
J.P.

Mayor's Parlour,
"Bodlondeb,"
Conway.

16TH JANUARY, 1939.

DEAR SIR (or MADAM),

GOVERNMENT EVACUATION SCHEME

The Council have been requested by the Government to co-operate in plans which are being made for the protection of civilian life in the event of war.

Recent experience in other countries has shown that under the conditions of modern warfare the greatest loss of life is caused by bombardment from the air. This danger is most acute in crowded cities. It is to lessen this danger in case our own country were involved in war that arrangements are being made now to enable children to leave the crowded cities and be received in homes elsewhere. This protection can only be given with the co-operation of those like ourselves who live in the less congested towns or villages. We all agree that it is necessary for all of us to help in this plan for saving human life, and for safeguarding the rising generation who will eventually have the management of our country in their hands.

I am aware that some arrangements were made last September as a matter of emergency. These had perforce to be improvised and sometimes gave rise to points of criticism. But I am sure that in the light of the experience gained we shall be able to improve on these. The plans for this, as for other branches of civil defence, must be made in time of peace. We hope that it will never be necessary to put them into operation. But we shall all be happier to know that the plans have been made and that if ever they do have to be put in operation, the work will be done in an ordered manner, and that all will know their parts.

The Government has asked each local authority in the country to find out what housing accommodation would be available in case of emergency, and what homes would be suitable for those children who would be given the means of leaving the great cities. It is particularly important to know in which houses homes could be provided for the children, where they could be lodged, boarded and cared for. Payment would be made by the Government at the rate of 10s. 6d. a week where one child is taken, and 8s. 6d. for each child where more than one is taken.

School children would be moved school by school, accompanied by their teachers, and arrangements would be made for the children to attend school in the districts to which they were taken.

A visitor appointed by Conway Council will call upon you shortly to find out how far you will be able to assist in this matter. The visitor will produce to you a card of authorisation to make these inquiries.

This note is sent to you now in order that you may be aware, in advance, of this enquiry and why it is being made.

I give you my assurance that the information supplied by you will not be used for any other purpose than that which I have described, and that it will not involve you in any work or responsibility unless and until an emergency arises. I feel that I can rely on the people of Conway Borough to offer all the help they possibly can in this important branch of civil defence. It needs no words of mine to convey to you what that help will mean to children of the big cities.

Yours faithfully,

E. D. ROWLANDS,

Mayor.

An open letter from the Mayor of Conwy appealing for residents to assist in taking child evacuees if the need arose.

From Conwy railway station evacuated children were first taken to the Guildhall and examined by the medical officer. After refreshments, they were taken to meet their foster families.

Williamson Art Gallery, Birkenhead, remained open during the war years, albeit without many treasured artworks that were removed to north Wales after the Blitz of 1941.

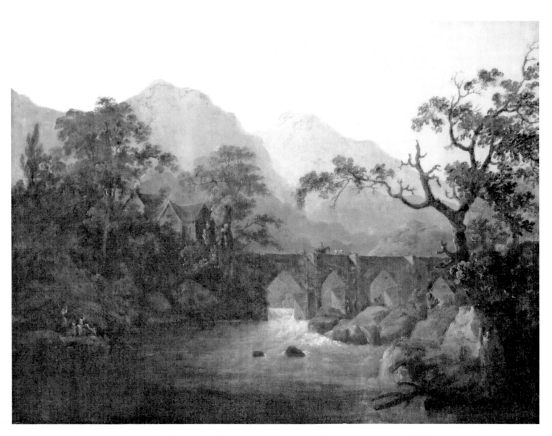

Old Welsh Bridge by Richard Wilson hung in the upper hallway of the council offices at Bodlondeb when removed from the Williamson Gallery. At that time, the oil painting was valued at £1,200 and was the most valuable of all the artwork that came to Conwy. (Courtesy of Williamson Art Gallery and Museum, Birkenhead (Wirral Museums Service))

15. Defending Conwy

Throughout history, dominance of the river crossing at Conwy was paramount for any military force whether defensive or offensive. With the opening of Thomas Telford's magnificent suspension bridge in 1826 and of Robert Stephenson's tubular railway bridge two decades later, crossing the watercourse became easier and so its defence was of even greater importance. During the First World War, both bridges were guarded for fear of attack from undercover German agents, with patrols undertaken by members of the Volunteer Training Corps. In April 1939, the Home Office instructed Conway Borough Council that the suspension bridge must be protected day and night with immediate effect. The perceived threat was not from Germany but Irish Republicans who were stepping up their bombing campaign on mainland Britain. Three unarmed, retired policemen were employed to patrol the bridge. Five months later, at the outbreak of the Second World War, the War Office deemed it essential to guard the railway bridge from enemy attack and sent a detachment of soldiers to Conwy; however, they were ordered not to protect the road bridge. The council was bemused: while the Home Office demanded its protection, the War Office did not deem it worthy of securing. The suspension bridge, the council pointed out, was the main trunk road between Holyhead and Chester and therefore a vital artery along the north Wales coast. A compromise was reached when the military informed the council that if it provided a hut for the men defending the railway bridge then they would 'keep an eye' on the suspension bridge too. The council acquired a hut belonging to the local Boy Scouts troop for £30 and relocated it to a position on the Llandudno Junction side of the cob. The hut was not in the best of condition for as well as letting rain in and wind through, light was emitted through the many cracks and crevices. The police threatened the council with prosecution for breaching the strict blackout laws and so the soldiers were forced to pack the joints and spaces with bits of old newspaper.

Prior to the redesign of the embankment to incorporate the road bridge in 1958, the rocky outcrop known as Ynys was landscaped with trees and shrubs and a popular location to watch the setting sun on a summer evening. All that changed in 1942 when the RAF decided that Conwy bridge would make the perfect bombing target, albeit a practice one. Three projectors were installed on Ynys, each emitting an infrared beam which aircrews attempted to line up and photograph in the aircraft's bombsights while on exercise. On landing, the images were processed to reveal whether a perfect hit on the bridge had been achieved or not.

May 1940 was a turbulent month in Europe. On the 10th German forces swept into Holland and Belgium and days later crossed the River Meuse at Sedan into France. The British Expeditionary Force, including many local men, was forced to retreat, the lucky ones being evacuated from the beaches of Dunkirk at the end of the month. Back in Blighty the government was anxious to mobilise as many men as possible for fear that Britain would be invaded next. The Minister of War, Anthony Eden, announced on

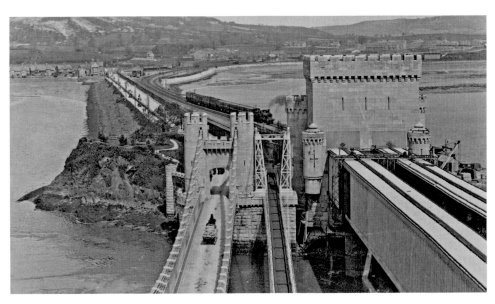

On the rocky outcrop behind Thomas Telford's suspension bridge the Royal Air Force installed infrared projectors in 1942.

At Conwy Morfa cylindrical concrete blocks have been installed to combat coastal erosion. They may well have been repurposed anti-tank devices used by the Home Guard as roadblocks during the Second World War.

64

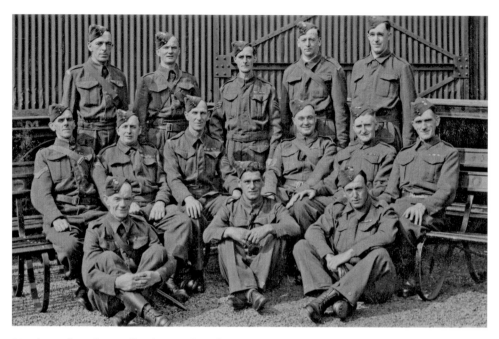

Members of London Midland Scottish Railway Home Guard at Llandudno Junction. (Courtesy of Roy Mills)

the wireless the formation of the Local Defence Volunteers (LDV) for men who were too young or too old to join the regular army or worked in reserved occupations. Later the LDV was renamed the Home Guard. Some 550 men from the district enrolled in B Company, 1st Battalion Caernarvonshire Home Guard, under the command of Major J. P. Gee, and were split into six platoons: one platoon each in Conwy and Deganwy and four in Llandudno Junction – one for the town, while LMS railways, Crosville buses and Ratcliffe Engineering each had their own.

The Home Guard regularly took part in exercises and competitions, the six local platoons competing against each other for the A W Ball Challenge Cup. These contests were to promote competence and inter-platoon rivalry in drill, bayonet fighting and Lewis gun practice. The only winners were the men from Conwy and Deganwy, with the four Llandudno Junction squads always trailing at the foot of the results table.

One of the biggest, and most memorable, exercises to test the efficiency and readiness of units in the area took place in August 1941. Known as the 'Battle of Conwy', it involved the Home Guard and Civil Defence services. The drill began when a boat carrying 'enemy spies' posing as fishermen came aside Conwy quay and the men made for the suspension bridge. One of the 'fishermen' was carried on a stretcher and when stopped on the bridge by a detachment of the Home Guard they claimed to be trying to get their wounded colleague to hospital. Disbelieving the story, the Home Guard marched the fishermen to the guard room for interrogation. Later that morning an 'enemy' plane – actually a twin-engine Royal Air Force bomber – swooped low over the castle dropping dummy high explosive and incendiary bombs onto the streets of Conwy and strafing the inhabitants

with blank machine gun bullets. It was the turn of civil defence personnel to leap into action, tending to casualties and dealing with the unexploded bombs. After the exercise had finished, organisers were quick to point out that had poisonous gas been dropped there would have been a great number of civilian casualties as three-quarters were not carrying their gasmasks.

'Enemy' bomber over Conwy during the 'Battle of Conwy', August 1941. (Courtesy of Conwy Archives Service)

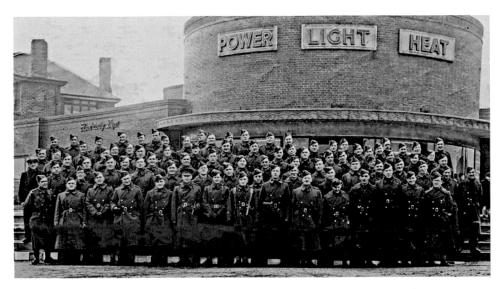

The Home Guard outside the electric showrooms in Llandudno Junction, November 1944. It was here that many had joined the battalion four years earlier. Robert Williams (in peaked cap on the front row) was known locally as Bob DCM on account of the Distinguished Conduct Medal he was awarded while serving with the Royal Welsh Fusiliers at Gallipoli during the First World War.

On the Sychnant Pass are the remains of anti-tank blocks constructed in 1940. They were built to counter a potential German advance inland towards Conwy. Defence forces were also ordered, in the event of invasion, to blow up the tunnels at Penmaenbach and Pen-y-clip, effectively leaving the enemy trapped on Penmaenmawr beach.

16. Ratcliffe Engineering

In February 1940, Conway Borough Council was approached by land agent and architect Sidney Colwyn-Foulkes with regard to building a large, modern factory on fields at Llandudno Junction to manufacture aircraft parts. The council's Town Planning Committee met as a matter of urgency and permission was granted. Built under the auspices of the Ministry of Aircraft Production, the factory was leased to the Ratcliffe Engineering Company, a subsidiary of Ratcliffe Gauge and Tool Company, which already had an operation in London making jigs, precision tools and machinery. Owned by Thomas Ratcliffe, his son Jack oversaw the Llandudno Junction plant and later ancillary works at Llandudno and Colwyn Bay.

Building work started immediately and the factory was completed and fully operational within eighteen weeks. Initially fabricating spars for Beaufighter aircraft, the RAF's principal night-fighter, these were loaded three at a time onto articulated lorries and driven to the Austin works at Longbridge in the Midlands for further assembly. Later in the war production expanded to include the manufacture of spars, bomb carriers and bomb release apparatus for Halifax bombers.

Post-war, the camouflage paint was still evident on the front of the former Ratcliffe Engineering factory. An anti-aircraft gun and searchlight installation was positioned in the grounds of the neighbouring Marl Hotel to protect the factory from the air.

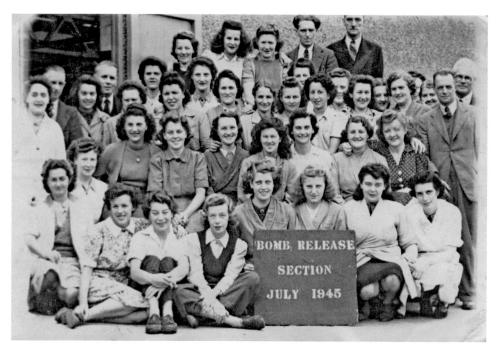

Bomb release assembly workers at Ratcliffe Engineering, July 1945. (Courtesy of Pete Cimatti)

At its peak, Ratcliffe Engineering employed 1,000 people drawn from across north Wales, workers travelling from as far as Flintshire and Anglesey. The factory operated a three-shift system and functioned twenty-four hours a day, seven days a week. While many workers found board and lodgings in local households, the former home of acclaimed landscape artist Joshua Anderson Hague was requisitioned for some workers. The property, 'Vardre' on Tŷ Mawr Road, Deganwy, has since been demolished and a modern block of apartments built in its place. From the factory's canteen, the BBC broadcast episodes of 'Worker's Playtime', a morale-boosting radio programme specifically for industrial workers. In May 1942, Thomas Ratcliffe welcomed the Duke of Kent (brother of King George VI) to his engineering works at Llandudno Junction. He was in north Wales fulfilling his duties as a Welfare Officer, touring RAF bases and Air Ministry factories to boost wartime morale. His visit was a surprise to the majority of the workers and he spent more than an hour chatting to them about their work and watching demonstrations. Three months later the Duke of Kent became the first member of the royal family to be killed on active service in more than 450 years when his plane crashed in northern Scotland.

A couple of Ratcliffe's employees caught the attention of the intelligence services who had covertly embedded their agents in the factory. Frederick Hodgetts of Conway Road in Llandudno Junction came under scrutiny after he painted a swastika on the rear wall of his home. When questioned he claimed that he had done so as the symbol was associated with good fortune in many eastern cultures rather than the icon synonymous with fascism. Hodgetts was the grandson of an Italian immigrant to Britain and for that

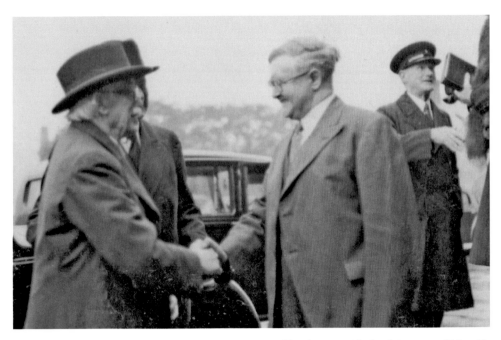

Thomas Ratcliffe welcoming former Prime Minister and local MP David Lloyd George and his wife Frances to his Llandudno Junction plant. (Courtesy of Jane Ratcliffe)

reason vowed never to fight against Italy or her German ally. Another colourful character employed at Ratcliffe Engineering was Reginald Hymus. He told his fellow workers that he was a Squadron Leader in the South African Air Force and was in Llandudno Junction 'on secret war work'. He related tales of derring-do and how he had been awarded the Distinguished Flying Cross and Distinguished Service Order for gallantry. Unfortunately for Hymus he was unable to dupe his colleagues, one of whom was a warrant officer with the local Air Training Corps squadron, and the matter was reported to Commander Keily, a veteran of the First World War and Ratcliffe's security supremo. Hymus appeared before Conwy magistrates charged with the unlawful wearing of medals and ribbons to which he was not entitled and was sentenced to three months in prison. It was not the first time either, nor would it be the last, for between 1933 and 1954 fantasist Reg was charged on twelve separate occasions with fraud and deception, culminating with a four-year stretch at York Gaol for obtaining food and lodgings by false pretences. On that occasion he told the arresting officers that his name was Hans Jensen von Hofmayer!

With the return of peace in 1945, the future for Ratcliffe's employees was far from assured. Despite initial reassurances that the factory would continue to manufacture products for the Board of Trade, albeit for civilian rather than military purposes, these contracts were cancelled. By mid-1946, the owners were looking to make staff redundant and sell the Llandudno Junction site. In 1947, the International Refrigerator Company expressed an interest in acquiring the site and took over the plant in April. Thus, the manufacturing of white goods began, assuring employment for many local residents for the next forty-five years until the closure of the Hotpoint factory in 1992.

Ironically car showrooms dominated by German marques Volkswagen, Audi and Skoda today stand where Thomas Ratcliffe's factory once churned out parts for Allied aircraft intent on destroying the same manufacturer's plants over eighty years ago.

17. Dolgarrog Decoy Site

Throughout history, wars have been fought by bluff and subterfuge as well as sword and bullet; think of Owain Glyndŵr's cousins' deceit to pass the castle guards at Conwy or the elaborate deception by British naval intelligence in *Operation Mincemeat*. During the Second World War, night-time decoy sites, using lights and fires, were created to mimic towns, airfields, military installations and industrial locations in the hope that German aircrew would bombard these instead of the actual target. Very few were established in north Wales with one at Newborough to replicate RAF Valley and a number in Flintshire and Wrexham protecting key industrial sites. On the road to Llyn Eigiau, a decoy was built to draw bombers away from the aluminium works at Dolgarrog after the factory, vital for aircraft production, came under government control in 1940. So important a site, it was also protected by pillboxes, anti-aircraft guns, anti-tank blocks and Allan Williams turrets – a revolving, steel cupola.

Some historians do not believe that this level of protection was solely for Dolgarrog's aluminium works, as vital as the factory was for the war effort. Many locals tell the story that the Crown Jewels were stored at a large country house in the locality during the war. Plas Maenan (known locally as Plas 'Jack' on account of it being the former home of Henry Jack, the managing director of the aluminium works) stands on the opposite side of the River Conwy to Dolgarrog. Its vast network of tunnels was home to important treasures from the British Museum during the Second World War. The Crown Jewels themselves are said to have been stored in a biscuit tin beneath Windsor Castle – or were they?

Today, the blast walls of the Dolgarrog decoy site are all that remain of the control bunker while the fire braziers, set up in the fields opposite, have long since been removed.

18. Prisoners of War

At the outset of the Second World War the UK imported almost three-quarters of its food requirements, mainly from her Dominions and the Americas. Even though Britain was only weeks away from starvation during the First World War lessons had not been learned in the interwar period and agricultural production had not increased, nor had conditions for farm workers improved; low wages and long hours meant it was hard to retain skilled agricultural workers. On the day Neville Chamberlain declared war, the German navy sank the British merchant ship SS *Athenia*, and so began the Battle of the Atlantic and three years of German U-boats sinking Allied ships, badly affecting imports. One response was to try and make Britain more self-sufficient and so the government set up War Agricultural Executive Committees, known as War Ags, to increase yields on farms and to turn previously uncultivated land into production. Demand for land led to public spaces, parks, golf courses and even sports pitches being ploughed up. With a shortage of labour, the Women's Land Army were mobilised to work on farms and military personnel, as well as evacuees, shop girls and office workers, to bring in the harvest. This changed in 1943 when large numbers of Italian and German prisoners of war were captured by the Allies in north Africa and shipped to Britain. In anticipation of this influx, the Ministry of Works instructed Caernarfonshire County Council that sites would be required to house the prisoners.

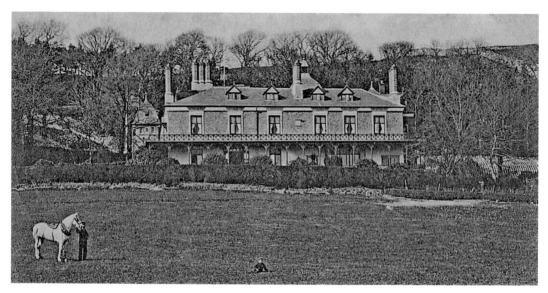

Pabo Hall on the outskirts of Conwy was built in 1866 for Edward Brooke, a wealthy industrialist.

One property requisitioned was Pabo Hall, which was utilised as an administrative centre from where German and Italian prisoners billeted in agricultural camps across north-west Wales were managed. Two of these camps, Bryn Estyn at Deganwy and Glan y wern at Ty'n y groes, were in the Conwy district. Detainees who volunteered to work were known as cooperators. However, if there were any disciplinary issues, including fraternisation with local women, they were relabelled as non-cooperators and transferred to camps with far fewer freedoms. Conditions at the agricultural camps were regarded by the prisoners as 'quite good', with newspapers and reading materials provided and study encouraged. Prisoners worked six and a half days a week and were paid a basic wage of one penny per hour. Jobs varied depending on the type of farm and the season, but generally the most onerous and physical were given to the cooperators. As well as agricultural work, they toiled on road maintenance, in local quarries and in 1945 helped demolish pillboxes and barbed wire entanglements.

After the war ended in 1945, prisoners' repatriation progressed slowly. During 1946, they carried out a fifth of all farm work across Britain, as well as working on roads and at building sites. However, tensions still existed. In April 1948, former German prisoner of war Heinrich Benedict appeared before Llandudno magistrates charged with beating and assaulting George Foster, a fellow labourer at Bryniau Farm, Llanrhos, at milking time. As Herr Benedict was unable to speak fluent English, a teacher of German at John Bright Grammar School was summoned to the court to interpret. Foster alleged that he was pouring milk into a bucket when Benedict attacked him from behind, held him in a headlock and pummelled him around the head, leaving him with a swollen eye and mouth and bruised chin. In his defence, Heinrich Benedict maintained that George Foster always referred to him as 'a Nazi' and 'a pig' and on this particular morning Foster had thrown a milking pail at him and so he had defended himself. The magistrate found Benedict guilty, fined him £1 and ordered him to pay £2 2 shillings costs.

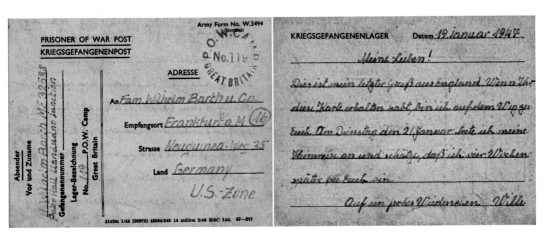

Postcard sent by Wilhelm Barth, a prisoner of war at Pabo Hall, to his family in Frankfurt. Dated 1947, it simply states 'This is my last greeting from England. When you receive this card, I'll be on my way back to you. I'll leave for my journey on Tuesday, 21st January and estimate that it will take me about 4 weeks to get to you. See you again soon, Willi'.

Special currency was printed for use by internees in prisoner-of-war camps to buy small luxuries and supplement the food provided. Sterling was not used in case captives escaped. (Courtesy of Home Front Museum)

In September 1944, there was a lockdown at all the prisoner-of-war camps administered by Pabo Hall after Italian cobbler Francesco Astolfo went missing. For some weeks the thirty-five-year-old had been suffering from acute mental health issues: depression brought on because he had not heard from his wife and children who he feared were dead, coupled with him suffering from a 'persecution complex' according to the British guards. On the 7th, Astolfo was being escorted across the Tal-y-cafn bridge from the camp at Ty'n-y-groes to a nearby farm, when he jumped onto the parapet. Despite the best efforts of his fellow countrymen, they could not hold onto him, his clothes slipped from their grasp and he plunged into the river below. The police were notified and a search instigated involving local fishermen and prisoners of war but it was in vain and eleven days later his body was recovered a mile north of the bridge.

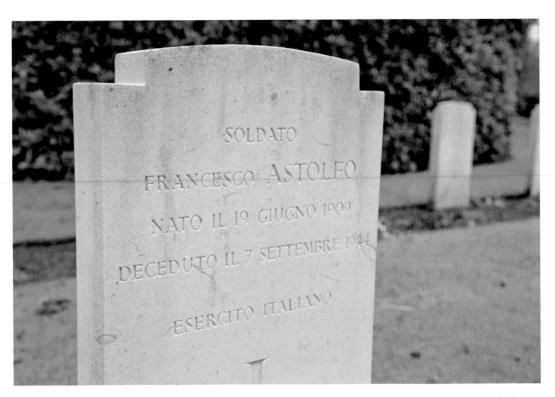

Francesco Astolfo was afforded a military funeral, his coffin draped with the Italian flag, when laid to rest at the Great Orme cemetery, Llandudno. In 1953, his body was exhumed and reinterred at the Italian section of Brookwood Military Cemetery, Surrey.

19. Cold Store

Food rationing was introduced in January 1940 and continued until 1954. Locally, Alderman Arthur Smith was appointed as the district's Food Executive Officer and chaired the Food Control Committee made up of councillors, horticulturists, food retailers, fishermen and housewives. As well as ensuring food was available for the population, its fair distribution was also a priority. In September 1939, work started to make Llandudno Junction the 'Billingsgate' of north Wales. Established by the Fish Trade Advisory Committee, the fish distribution centre served an area extending from Llangollen in the east to Aberystwyth in the west and all points north. It was supposed to alleviate a shortage of fish but despite workers from Grimsby building special sidings and storage areas, fishmongers still complained that supplies did not improve when the distribution centre opened.

In 1942, the Ministry of Food appointed John Gill of London to build a cold food store at Marl. The site was chosen due to its central location in north Wales and its proximity to the main line railway. Sidings were laid into the depot, which was utilised to store meat, butter and other chilled foodstuffs. In 1944, thousands of American troops descended

Marl cold store photographed shortly before the A55 trunk road was constructed. The original air-raid shelter was still evident, although the railway sidings had gone. (Courtesy of Trefor Price)

on Conwy, Llandudno, Colwyn Bay and Bangor in the build up to D-Day in June that year. This led to an extensive logistical operation by the US Army to supply its troops with everything they needed and they took over part of the cold store. The 308th Quartermaster Railhead Company under the command of First Lieutenant Crow were in charge of bringing supplies into north Wales, even bringing their own steam locomotives with them, which were easily distinguishable from British-made engines by the larger capacity water tanks. At the cold store the US Army's 484th Quartermaster Refrigeration Company was responsible for coordinating supplies to its troops across Denbighshire and Caernarfonshire. During the Cold War it was planned to adapt this cuboid, utilitarian building into suitable headquarters for local government in north Wales but this did not materialise. In 1979, a compulsory purchase order from the Welsh Office took much of the land around the front and rear of the building in order to move the main line railway to make way for the construction of the A55 Expressway.

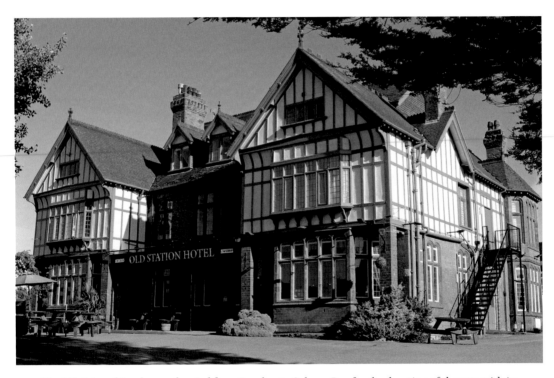

The Ministry of Food was relocated from London to Colwyn Bay for the duration of the war, with its headquarters at the Colwyn Bay Hotel. The government minister responsible for this department was Lord Woolton, who was billeted at the Station Hotel in Llandudno Junction.

20. The 'Mulberry' Artificial Harbour

Today locals and holidaymakers walk their dogs, paddle in the water and laze on the beach at Conwy Morfa, but many do not realise the role this area played in helping rid Europe of the tyrannous Nazi regime. In October 1942, Conway Borough Council was contacted by Holloway Brothers, a London building contractor, with orders to requisition land at Conwy Morfa for 'urgent war work' which was a 'vital secret'. Holloway Brothers had previously built Gorringes department store and the Old Bailey, both in central London, as well as many other notable buildings in the capital. They also demanded the details of the owners of 'Beacons', a large Victorian residence on the foreshore, the former home of Arthur Woodhead, a Huddersfield newspaper proprietor. The house was in fact divided into two properties, with 'South Beacons' already commandeered by the council under the evacuation scheme. Those Liverpool evacuees were ordered to pack up their few possessions and move to Bryn Rhedyn on Sychnant Pass Road in order for the property to be used as offices and stores for Holloway Brothers. With the land and 'Beacons' secured, work started on sections of a prototype floating harbour designed by Bangor born engineer Hugh Iorys Hughes for use in the future invasion of mainland Europe. When the Allies opened up that new front, they were convinced that they would not be able to get all the men, equipment and supplies ashore without such a system. Commodore John Hughes-Hallett, Naval Chief of Staff, remarked 'If we can't capture a harbour, we must take one with us'. Over 700 workers including carpenters, steel erectors, welders and labourers, as well as office staff, were employed at the Morfa and accommodation had to be found for them all. The council was so worried about finding the necessary housing that they considered sending people out of the borough who had arrived in Conwy after a certain date. Ultimately, this was not necessary as enough accommodation was secured for workers at Plas Mariandir in Llanrhos, Ty'n-y-coed and High Pastures in Deganwy and the Friendship Holiday Camps at Bryn Corach and on the Morfa. Buses carried the workers to and from their billets to the construction site.

Working conditions on site were poor, with little or no cover from the elements and men riveting and welding at great heights. Residents got used to the hammering and striking at this new 'shipyard' but, with the government mantra of 'Careless Talk Costs Lives', asked no questions. In May 1943, the first of the experimental 'Hippo' sections was launched into the Conwy estuary, which was closed to all maritime traffic. Residents in Deganwy knew of the impending launch because sandbags were piled up along the promenade in case the 3,200-ton concrete and steel leviathan caused a tidal wave. Royal Engineers were on hand to fasten an anchor cable and wire to the concrete pontoon, tethering it to mooring blocks on the Deganwy side of the estuary. Once launched, the individual parts making up Hughes' prototype harbour were towed to south-west Scotland and joined two other experimental temporary harbours for trial. Hugh Iorys Hughes' design was not chosen.

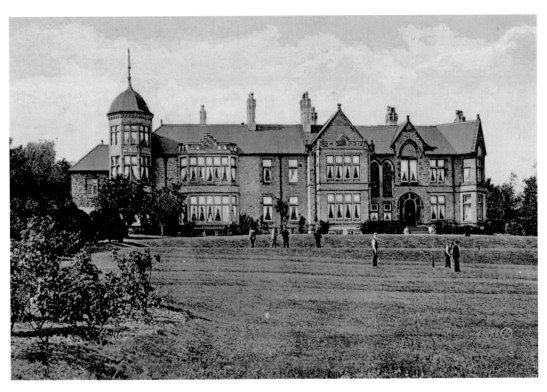

Ty'n-y-coed Convalescent Home was opened by Birmingham Hospital Saturday Fund in 1892 and housed men working on the 'Mulberry' artificial harbour project.

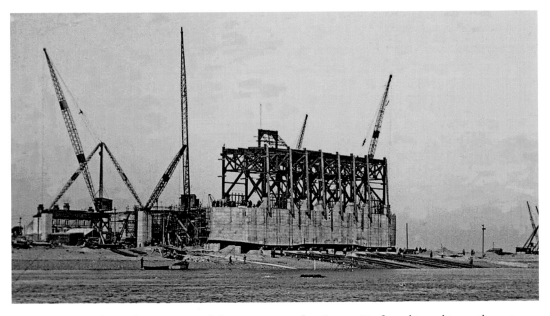

A prototype 'Hippo' section, one of three, constructed at Conwy Morfa and towed to south-west Scotland for testing. (Courtesy of Conwy Archives Service)

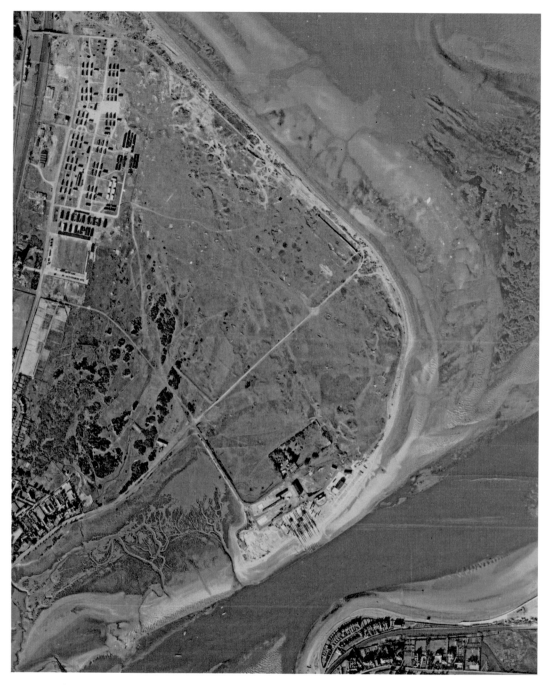

Aerial photo of Conwy Morfa taken by a Royal Air Force photographic unit in 1945. The slipways built to launch sections of the 'Mulberry' artificial harbour are visible on the shoreline. The army camp can be seen in the top left corner. (Courtesy of Welsh Government – RAF 106GUK735/3013)

Stone from nearby quarries was used in the production of the concrete caissons used in Iorys Hughes' prototype designs.

In June 1943, the council was informed that the land at Conwy Morfa would no longer be required after the successful launch of the prototypes. However, in September that year Holloway Brothers and Joseph Parks & Son of Northwich were awarded the contract to construct sections of the now finalised artificial harbour design and the decision was reversed. Further land was also required to build a road across the golf course to the Morfa sidings at the disused stone-breaking plant belonging to the North Wales Granite Company on the main Chester to Holyhead railway line.

Between September 1943 and April 1944, pierheads fabricated at Joseph Park's Cheshire foundry were assembled at Conwy Morfa, floated and towed to the south coast of England. On the Normandy beaches, these were connected together with sections of roadway built elsewhere and became operational just four days after D-Day, 6 June 1944. Travelling with the artificial harbour was a detachment of the Inland Water Transport Operating Company, Royal Engineers, who had been headquartered at 'The Moorings', Morfa Road, while the sections were fabricated. One of the Royal Engineers who helped build the harbour on 'Gold' beach at Arromanches-sur-Mer was Sapper Robert Craven, son of a Conwy fishermen. He had served in the army for ten years, initially with the Royal Welch Fusiliers before transferring into the Royal Engineers, and helped to bolt together the giant 'Meccano' set. The artificial harbour at Arromanches was an immense success. It is estimated that in the ten months it was operational over 2.5 million troops, 50,000 vehicles and 6 million tons of supplies were landed.

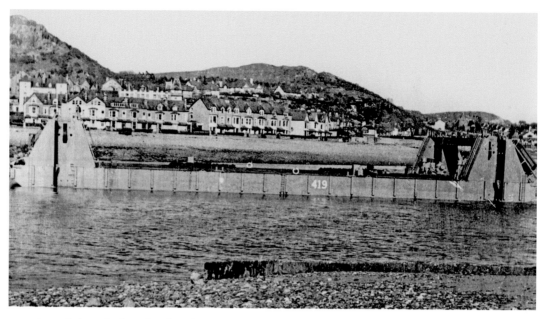

A newly launched pierhead anchored in the estuary after assembly at Conwy. Once in position in Normandy, thousands of men and tons of equipment passed over them. (Courtesy of Conwy Archives Service)

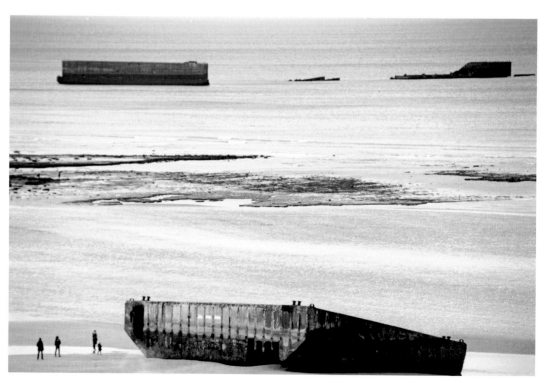

Duty done: concrete caissons lie on the beach at Arromanches-sur-Mer, Normandy.

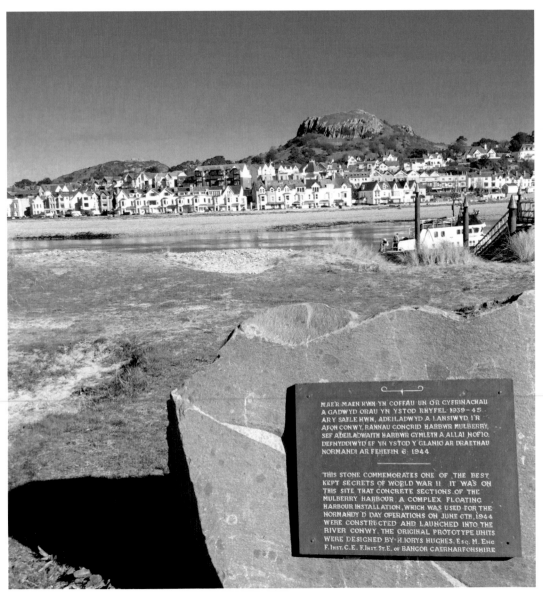

Plaque to commemorate the building of sections of the artificial harbour was unveiled by Major General Stewart Cox on the anniversary of D-Day, 1978. Fittingly the slate tablet was mounted on a boulder from the same quarry where much of the aggregate used in the concrete of the prototype sections was garnered.

21. Aircraft Crashes

There were a great many aircraft crashes, both Allied and German, in north Wales during the Second World War. The Conwy district did not escape these tragedies, partly because Conwy Castle and nearby Great Orme's Head were prominent landmarks used by aircrews practising their navigation skills. In February 1944 an Avro Anson, on a training exercise, crashed with the loss of five crew at Marl Woods, close to the modern-day entrance of Bodysgallen Hall. The Anson had earlier taken off from RAF Mona on Anglesey on a routine training flight but disaster struck over Llandudno when, according to the crash investigation report, an aileron broke away causing the pilot, Flight Sergeant Samuels, to lose all control of the twin-engine trainer.

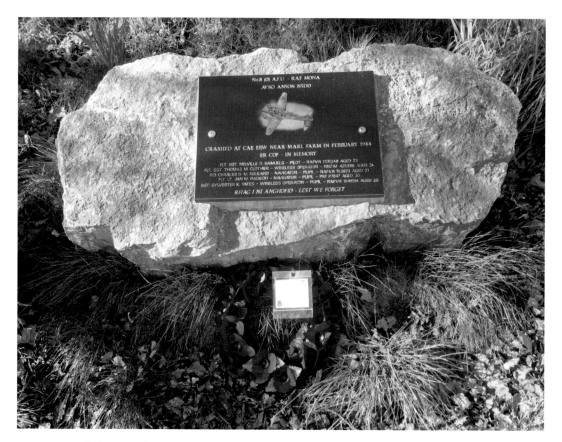

Memorial plaque to the crew of Avro Anson N5130 unveiled in February 2014, seventy years after the crash.

There are no traces of the crash that claimed five young airmen's lives in 1944, today commemorated by a plaque erected by a local history society.

Nine months after the loss of the Avro Anson, a second plane came down less than a mile away at Bryn Pydew. In October 1944, a Handley Page Halifax took off from RAF Wombleton in North Yorkshire with a crew of seven airmen – six Canadians and one Briton. They were on a routine night training exercise to Reading then onto Bath, over the Bristol Channel and back to Yorkshire. Problems arose and the skipper, Flight Lieutenant Harold O'Neil, turned on the plane's autopilot function and set a course out to sea. He ordered the crew to abandon the aircraft and they parachuted out of the stricken Halifax. Unfortunately, the plane turned over Llandudno and shortly before midnight crashed into a farmhouse on Bryn Pydew where farmer Zachariah Jones, his wife Jane and fifteen-year-old son had a remarkable escape. Their first intimation of the unfolding drama was when sheepdog Pero, who always slept in the cowshed, managed to escape and was barking wildly outside as though warning the family. When Jane Jones opened the door, she saw that everything in front 'was a mass of flames'. The plane had hit an outbuilding attached to the side of the main farmhouse, destroying it completely. Zach Jones lost two cows, a heavily pregnant sow (although the litter was delivered and survived), and one of his horses was blinded. Two cats, asleep in the cowshed with Pero, were also killed. Astonishingly, their son, John Glyn Jones, slept through the whole event, only waking when his mother stirred him. After striking the property the Halifax ploughed across the road and into a field, setting several hedges on fire as well as the farmer's hay barn. The

flames were doused by Llandudno's National Fire Service commanded by Chief Officer Jack Edwards aided by soldiers from the nearby searchlight battery who secured the site. Zachariah and Jane Jones returned to the farm the following day, having spent the night with neighbours, and began to assess the damage. It was some time before they were able to resume farming and seek compensation for their losses. The bulk of the aircraft was removed by the RAF, who loaded it onto a 'Queen Mary' articulated trailer, no mean feat for the driver on Bryn Pydew's narrow lanes. For years afterwards small bits of wreckage could be found in surrounding fields.

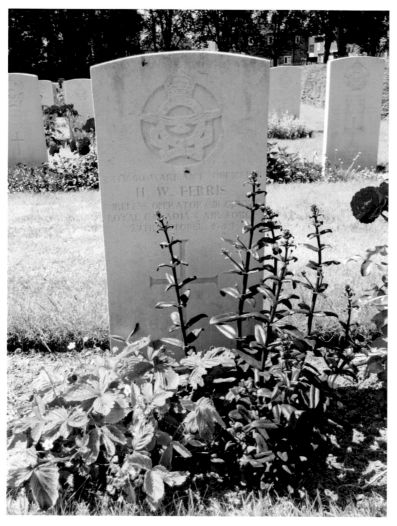

From the stricken Halifax the crew all landed safely except for the Wireless Operator, Pilot Officer Henry Ferris, who failed to attach his parachute correctly. His body was recovered from a field on the Sychnant Pass above Conwy. The Canadian was buried at Blacon Cemetery, near Chester, a couple of rows away from New Zealander Malcom Clothier, who died in the Avro Anson crash at Marl Woods nine months earlier.

On a windswept plateau above Penmaenmawr is a memorial stone dedicated to five American airmen and their dog, Booster. They were killed when a B-24 Liberator bomber crashed in low cloud on 7 January 1944. The aircraft, named 'Bachelors' Baby' by its crew, had left Palm Beach, Florida, a month earlier and taken the southern air route to Britain via Puerto Rico, Trinidad, Brazil, then across the Atlantic to Dakar, Marrakech and onto RAF Valley on Anglesey. After refuelling they were due to fly from RAF Valley to RAF Watton in Norfolk where the American Air Force had a base. The pilot of the Liberator was twenty-six-year-old Adrian Schultz, known to his mates as 'Ace'. He was born in Omaha, Nebraska, and when he left school worked at a meat packing factory and then as a salesman for a photographic firm. In 1941, with war raging in Europe and the possibility of America being involved, Shultz enlisted in the US Army Air Corps. After basic training he specialised as a bomb aimer but in 1942 applied and was accepted for pilot training. By September 1943 he was a certified bomber pilot.

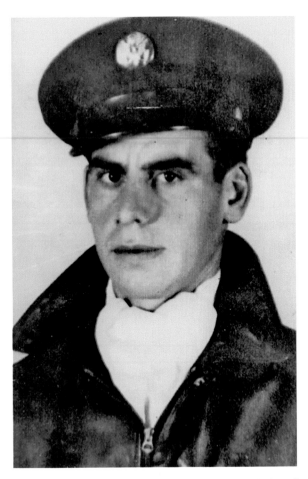

Staff Sergeant Samuel Offutt was the engineer aboard 'Bachelors' Baby'. He had graduated from Baltimore University Law School in June 1941 and enlisted in the air force the following September, a decision his father was not happy about. (Courtesy of Helen Brown)

On that fateful afternoon the Liberator took off from RAF Valley with a crew of eleven and orders to follow a B17 'Flying Fortress' that was to act as escort to its new base in eastern England. Impeded by dense cloud and drizzle, they lost sight of the chaperone except for an instant when the clouds broke and with it the realisation that they were flying too low. Despite the best efforts of Ace Schultz, the aircraft struck a ridge, bounced over a barren, heather-clad plateau and burst into flames. The plane was carrying a huge cargo of ordnance and on impact the ammunition started to explode. The surviving airmen struggled valiantly to help their stricken comrades who were trapped in the burning airframe but sadly for some it was too late and three airmen died at the scene and two in hospital the following day.

The bomb aimer Second Lieutenant Norman Boyer managed to make his way down to a farmhouse near Rowen and raise the alarm, although local quarrymen and the village policeman had already arrived at the crash site after seeing the bomber in difficulty. They administered what aid they could before carrying the injured down the mountain to Penmaenmawr where they were treated by a doctor and then taken by ambulance to hospital, in Bangor. Before being transferred to hospital Sergeant Harold (Hal) Alexander, a gunner on the aircraft, pleaded with quarryman Ellis Lewis to go back to the crash site and bury Booster. Mr Lewis obliged and interred the little black and white fox terrier close to the burnt-out aircraft.

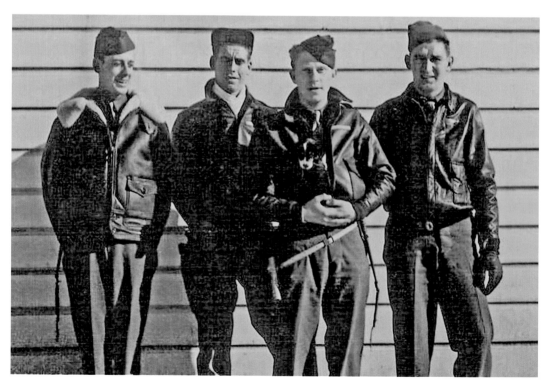

Four of the Liberator's crew with their canine mascot, Booster. (Photo courtesy of Helen Brown, whose brother, Samuel Offutt (second left), died in the crash)

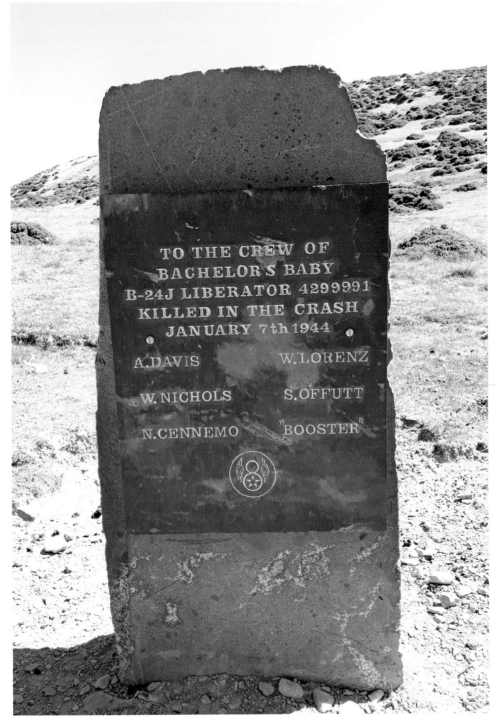

TO THE CREW OF
BACHELOR'S BABY
B-24J LIBERATOR 4299991
KILLED IN THE CRASH
JANUARY 7th 1944

A.DAVIS W.LORENZ

W.NICHOLS S.OFFUTT

N.CENNEMO "BOOSTER"

Today the crash site where 'Bachelors' Baby's' journey to Europe ended so abruptly in January 1944 is a scar of exposed earth where nothing grows. In 1980, a slate memorial was dedicated to the aircrew and their dog who died.

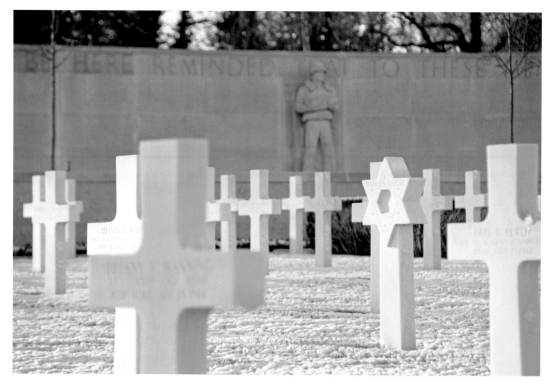

A number of the casualties were buried at the American military cemetery near Cambridge while others, including the body of Staff Sergeant Samuel Offutt, were repatriated to the United States.

The demise of military aircraft in the Welsh mountains did not end with the conclusion of the Second World War. Behind Conwy lies Tal-y-fan, the northernmost peak in the Carneddau mountain range, standing 2,000 feet above sea level. It is an ancient landscape of prehistoric settlements characterised by the Maen-y-bardd dolmen, Caer Bach hill fort and the isolated St Celynnin's Church. Tal-y-fan had already claimed the lives of five young airmen in August 1943 when they crashed while on a training flight, and fourteen years after the end of the war, the mountain took a further three. In May 1959, an Avro Anson belonging to Coastal Command was ferrying Group Captain John Preston from his headquarters in Hertfordshire to an RAF station in Northern Ireland. With deteriorating weather, instructions were radioed to the pilot to divert to RAF Valley on Anglesey. Nothing was heard of the plane after it had passed over Rhyl until the wreckage was located in a remote and lonely position on Tal-y-fan.

Today, only this small piece of wreckage remains amongst the heather and bilberry of the Avro Anson that crashed on Tal-y-fan in May 1959.

22. Freedom of Conwy

With more than a century of association between Conwy and the Royal Welch Fusiliers, and many men from the town serving with the regiment, the council bestowed the Freedom of the Borough on the regiment. At a ceremony at Bodlondeb Park in 1958, serving soldiers and veterans were inspected by the Mayor of Conwy and General Sir Hugh Stockwell, colonel of the regiment. The oldest man on parade was William Johnson of Victoria Drive, Llandudno Junction, who joined the Royal Welch Fusiliers in 1890 when he earned sixpence a day. He served during the Boer War, at the relief of Ladysmith and

Ceremonial Pioneers, wearing white buckskin aprons and gauntlets while carrying traditional tools, marched through Conwy as the Royal Welch Fusiliers were bestowed the freedom of the town.

Mafeking, before serving in India for ten years. During the First World War, Bill was an instructor with the Royal Welsh Fusiliers and then a senior non-commissioned officer with the Home Guard during the Second World War. Led by the regimental goat 'Billy' and with bayonets fixed, the soldiers marched through the walled town, adorned with flags and bunting for the occasion. The salute was taken opposite the Castle Hotel and while the men marched to Llandudno Junction for tea and sticky buns at the Hotpoint factory, the officers attended a gala dinner at the Castle Hotel. That evening the band of the Royal Welch Fusiliers 'beat the retreat' on Castle Street in front of a large crowd of onlookers.

Today, the people of Conwy continue to remember all those from the town who fell in war, with hundreds gathering at the war memorial for a service on Remembrance Sunday. Elsewhere in Conwy, Llandudno Junction and Deganwy volunteers annually place poppies on properties where servicemen who went away to war but did not return home once lived. (Courtesy of and © Rhodri Clark)

Conwy is considered the jewel in north Wales' tourism crown, with the castle attracting hundreds of thousands of visitors every year and an integral part of the local economy. As one of the best-preserved medieval castles in Europe it was designated a World Heritage Site by the United Nations in 1987. Events highlighting the town's military heritage are regularly held including the annual medieval torch lit parade every December. (Courtesy of and © Combat Wombat Inc./John Sutton)